POPULAR
PHOTOGRAPHY

GET THE
PICTURE

DAN RICHARDS

weldon**owen**

TABLE OF CONTENTS

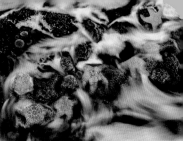

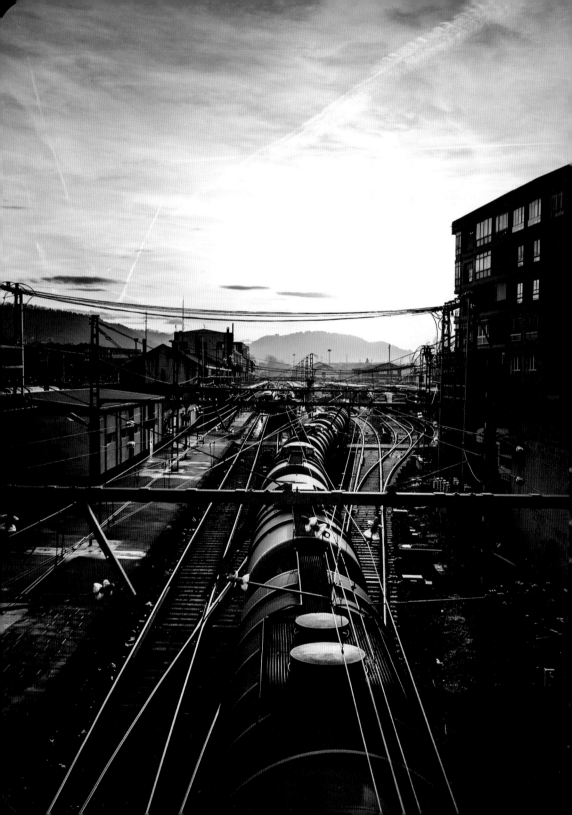

INTRODUCTION

My life changed in high school.

Relax. This is not some sappy coming-of-age story. Just a tale of an overgrown sixteen-year-old kid who got appointed to the yearbook staff and had access to, you know, real cameras—things with knobs and dials and click-stops and scales in millimeters (!). What a tantalizing pile of contraptions was strewn about the squalid little clubroom referred to as the Yearbook Office: A massive, wrist-busting press camera, a junky little 35mm viewfinder model, a light meter, flash units, and . . . *it*.

It was a pretty thing, chrome and black leatherette, of East German make, but at first puzzling—there was no viewfinder window. How would you compose the picture? I picked it up and looked into a small eyepiece on the back and realized I was looking through the "taking lens."

It was a single-lens reflex camera. I realized at that moment there was no going back for me.

With that camera, and lots of others, I learned through trial and (ahem) some error that, despite apparent complexity, "real cameras" had only three essential controls: focus, shutter, and aperture. I took pictures like crazy, all kinds, some of them professionally.

But the lifelong passion that was genuinely inspired in me was something else. I wanted to teach. I wanted to let other people in on the wonder.

And so I've now spent more than thirty years writing about the craft of photography, mainly for *Popular Photography* and its book series. In all that time, I've taken an approach that runs counter to that of many other writers and teachers. I don't give a hoot if you never use manual exposure. I want you to get out and shoot, shoot, shoot with your DSLR or ILC, and stoke the passion for seeing and making pictures—and most important, to learn how light works. And then we can get to all those nuts and bolts.

That's why this book is organized the way it is, with as little technical blather as possible at the beginning, and more toward the end for those who stick with it. If somewhere along the way I convey the giddy marvel of a kid composing a photo through a pentaprism for the first time, I've done my job. Please let me know.

And oh, the warning: There will be no going back for you, either. You'll end up using your phone as a phone. Sorry.

Dan Richards

DAN RICHARDS
Contributing Editor, *Popular Photography*

Photo
Primer

001 PREP YOUR CAMERA FOR QUICK SHOOTING

So you've unpacked your shiny new camera. Now what? You probably want to immediately start taking pictures—not spend hours reading the instruction manual. And who can blame you, since it's 300 pages long with tiny type? (Please note that, while I bad-mouth the manual often, it's a critical guide to your specific camera's functions. So keep it handy, and use the contents list or index to quickly locate your answer—don't attempt to read it in its entirety unless you've landed yourself on that proverbial desert island.)

Right now, my goal is to get you shooting as soon as possible, so let's set up the camera so it's ready for your first photo excursion. Here's the general gist to prepping your camera for action.

STEP 1 Juice up the battery. The rechargeable battery packaged with your camera may come with a partial charge on it or none at all. In any event, charge it fully before you start shooting, following the directions in the manual. It may take several hours to reach full power, so practice patience.

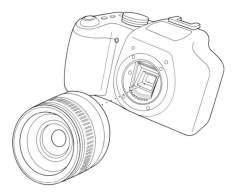

STEP 2 Attach the lens to the camera. The lens and camera body almost always come as separate pieces. To mate them up, first remove the protective caps from the camera body and the rear of the lens. Twist them off counterclockwise, like removing a jar lid. Match the mark on the rear of the lens with the one on the lensmount, insert the lens into the camera body, and twist clockwise until they lock together with a distinct click. (One exception: On Nikon cameras, both caps twist off clockwise, and the lens mates with the camera counterclockwise.)

STEP 3 Insert the battery. Its compartment is usually accessed via a hinged or sliding hatch on the camera's bottom. Open it and insert the battery so that its metal contacts go in first. If the battery doesn't go in all the way or the hatch won't close, you've inserted it the wrong way. Reorient the battery and try again.

STEP 4 Insert the memory card. Almost all current digital cameras use Secure Digital (SD) cards, although some take the larger Compact Flash (CF) cards. The memory card goes into a covered slot on the side or bottom of the camera, and—like the battery—it goes in terminal end first. If your card won't slide in fully, flip it and try again.

STEP 5 Turn on the camera. Usually it's obvious where the On/Off switch is, although sometimes it's not—for instance, if it's a small button tucked in a corner. Check the manual if it's hard to find.

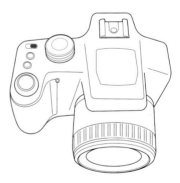

STEP 6 Format the memory card. This procedure readies a new card's file structure to properly record images. Check that manual again for the directions—it's done via the camera's menu system, and it's usually not very obvious.

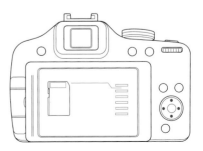

002 KNOW YOUR CAMERA

There are two main styles of interchangeable-lens camera on the market today. The most popular is the *digital single-lens reflex* (DSLR), which views through the lens via a complicated optical system: The scene is reflected by a mirror up to a prism, which flips the image right side up and unreversed to display in the viewfinder or on the LCD screen (see #006). The mirror then hinges up out of the way at the moment of exposure. However, an *interchangeable-lens compact* (ILC) dispenses with the prism and mirror, delivering a direct electronic feed from the imaging sensor to the viewfinder—hence they are called "mirrorless."

Regardless of style, today's cameras come covered in more buttons, dials, and control pads than the cockpit of the space shuttle. Sorting out what they all do, however, does not need to be rocket science.

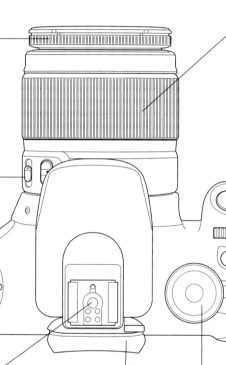

MANUAL FOCUS (MF) RING
Switch your lens out of autofocus (the switch is on, or near, the lens), and you can decide for yourself where to focus by turning this ring. Some lenses let you fine-tune autofocus with it as well. Note that some lenses do not have an MF ring.

ZOOM RING Turn this to adjust for wide or long focal length to make your subject appear nearer or farther away. Some cameras may have power zooms, operated by a switch on the lens barrel.

IMAGE STABILIZATION SWITCH This control may be on the lens or on the camera. Lets you shoot static subjects with the camera handheld at shutter speeds that would ordinarily blur the image.

COMMAND WHEEL On most cameras, you can control shutter and aperture via a command wheel. Some cameras have two—a plus.

HOTSHOE Used primarily to attach an accessory flash (see #139–149) and other helpful accessories. It is much more than a simple trigger–it can convey lots of information between the camera and shoe-mounted accessories.

LIVE VIEW BUTTON Push this button to switch your DSLR from the optical eye-level viewfinder to viewing on the LCD monitor.

MODE DIAL This dial lets you pick a totally automatic way of shooting, an auto mode (like P) that lets you have some say in making the settings, or a manual mode that lets you be the boss all the way.

AUTOFOCUS BUTTON Press this button to select the elements in a scene that you want to appear in sharpest focus.

003 SKIP AUTO AND PARK IT IN P (FOR PROGRAM MODE)

Now that you've charged and installed your battery, attached your lens, formatted your memory card, and learned where some important functions are located, it's time to turn your attention to choosing an exposure mode. For a lot of folks, this is where it gets intimidating.

Your camera likely has a setting to make all exposure decisions automatically—it might be called *autoexposure* or have a fancier name like *scene intelligent auto*. The manual will tell you to start with this mode, but trust me: Do not start with this mode. It requires you to surrender too much control, and it can be a serious barrier to learning. Instead, use the mode dial to set your camera to *program* (P) *mode*. Don't get nervous—this is still an automatic setting, but it lets you override the camera's robotic decision-making. For example, P mode lets you explore shutter speed's effects on action (see #039–048) and how aperture impacts depth of field (#049–054). You can also decide when to fire the built-in flash (#071–075). But in auto, the camera makes these decisions, so stay out of it! Once you're familiar with the camera's functions, we'll move into manual (M) mode (see #066–070).

CONTROL CORNER
FIND P MODE

Physical dial The simplest: Just turn to P.

Quick menu Touch a button to bring up choices on the LCD screen, and either scroll to or rotate a soft dial to select P.

Touchscreen Touch an icon to activate mode choices, and touch the P selection.

004 OPTIMIZE SETTINGS FOR YOUR FIRST PHOTO EXCURSION

Let's take care of some basic housekeeping before we shoot.

SELECT THE ISO In P mode, you can set ISO, which determines the digital sensitivity of your camera to light—and thus how well it handles low light and fast-moving subjects. We'll learn more about ISO later (see #055–058), but for now I'm going to shock some photography teachers by telling you to set it initially at 800, a pretty high sensitivity.

SET AUTOFOCUS Make sure the focusing switch (it's on the lens, or on the camera close to the lensmount) is set to S, which stands for single-shot autofocus.

PICK IMAGE STABILIZATION Your lens or camera body likely has an image stabilization switch, possibly called "anti-shake" or "steady shot." Turn it on and leave it on. It's like chicken soup: It can never hurt, and it can help a lot—and often.

COAST ON AUTO For the rest of the settings, stick with the standard settings on the camera when it comes out of the box. Check them if you want: White balance will be set to auto (AWB), autofocus area to multipoint auto (it allows focus anywhere across the frame), and drive to single frame (which shoots one shot at a time).

TAKE OFF THE LENS CAP Don't be that shooter.

005
SUPPLEMENT YOUR BASIC CAMERA BUNDLE

In general, I'm all for encouraging you to start shooting with the most basic tools—often, everything you need to get going is packaged with your camera. But depending on the make and model you've purchased (or if you've gone rogue and bought a camera body and lens separately), you may be lacking these inexpensive but essential items.

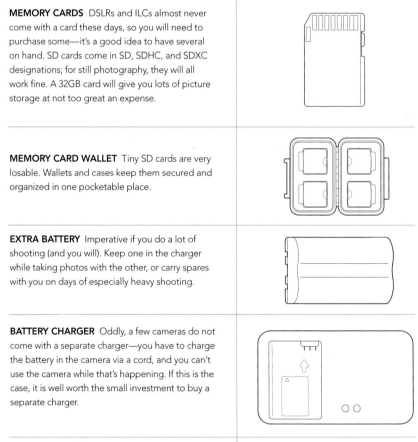

MEMORY CARDS DSLRs and ILCs almost never come with a card these days, so you will need to purchase some—it's a good idea to have several on hand. SD cards come in SD, SDHC, and SDXC designations; for still photography, they will all work fine. A 32GB card will give you lots of picture storage at not too great an expense.

MEMORY CARD WALLET Tiny SD cards are very losable. Wallets and cases keep them secured and organized in one pocketable place.

EXTRA BATTERY Imperative if you do a lot of shooting (and you will). Keep one in the charger while taking photos with the other, or carry spares with you on days of especially heavy shooting.

BATTERY CHARGER Oddly, a few cameras do not come with a separate charger—you have to charge the battery in the camera via a cord, and you can't use the camera while that's happening. If this is the case, it is well worth the small investment to buy a separate charger.

LENS HOOD If you've acquired a camera with a kit zoom lens, chances are it came without a lens hood. It's a good idea to get one; it keeps stray light from causing lens flare and protects the front of the lens from whacks and fingerprints.

006 PICK A VIEW

Before you photograph a scene, it helps to be able to view it. Today's cameras come with one or two options for doing so.

LCD MONITOR If your camera is on a tripod or being used at an extreme angle, you may opt to view via the *liquid crystal display* (LCD) monitor. All ILCs and recent DSLRs show the scene via live view (in which the image is sent from the sensor to the monitor). If your camera has an articulated LCD screen, try this: Flip up the LCD and hold the camera at waist level against your body. (I call it the belly brace.) It will steady the camera and let you focus more closely on your composition.

EYE-LEVEL VIEWFINDER All DSLRs and many ILCs come equipped with an eye-level viewfinder, thanks to either a mirror-and-pentaprism system (in DSLRs) or a direct feed from the sensor to the eyepiece (ILCs). In either case, an eye-level viewfinder helps you hold your camera steadier and concentrates your view on what's in the frame. It also displays your exposure settings right below the frame.

007 GET A GRIP

The way you hold your camera has a tremendous effect on your photos, as shaky hands do not make for crisp shots.

STEP 1 Grip the camera firmly with your right hand with your index finger on the shutter button. You should be able to depress the shutter without moving the rest of your hand.

STEP 2 Cradle the camera in your left hand, with your palm facing up. Use this hand to adjust the lens to zoom or focus.

STEP 3 Keep your elbows tight against your body—it'll help brace the camera and prevent image shake.

STEP 4 Bring the camera up to your face so the viewfinder rests against your eyebrow bone, which adds another point of contact for greater stability.

STEP 5 Balance the rest of your body. Take an even stance and look for other surfaces (walls or tables) that you can lean onto for support. If you need a lower point of view, bend your knees, not your back.

STEP 6 Squeeze the shutter button. Some people hold their breath momentarily—I do—while others find a slow exhale makes for a smooth release.

008 WAKE YOUR CAMERA WITH THE HALF-PRESS

The shutter button is the instant On switch for a whole raft of functions. Press it down halfway, to the point where you feel some resistance, and your camera goes live: Autofocus focuses the lens on your subject; autoexposure meters the light and sets exposure; the viewfinder and/or LCD monitor displays these settings; image stabilization starts up; and, if you activated the built-in flash, it gets a jolt of volts to prep it for firing.

All this is good stuff. But here's the most important part: If you maintain that crucial half-press, it locks in the exposure and focus until you press the button fully to snap the picture, which lets you explore composition without constantly tweaking settings. It's well worth practicing the half-press so it becomes routine. Compose a picture, lock in the settings with the half-press, and then try new angles—all the while holding the half-press.

QUICK TIP

009 LOOK (AND LISTEN) FOR FOCUS

Go ahead, take aim at a scene. You'll see a small square pop up over your subject, which indicates where the camera has focused. You can use various autofocus settings to select where it homes in—choosing, for instance, between the kite and the little boy in the image at right—and how it tracks your subject once focus is achieved (see #031–032 for more information). A green focus-confirmation lamp will also light up on either the viewfinder or LCD when you've locked on to your subject, accompanied by a cheerful beep. (You can turn that sound effect off if it irks you.)

010 TAKE CARE OF THE ITTY-BITTY NITTY-GRITTY

Yes, these are nagging and nerdy considerations for a first-time shooter, but yes, they will make shooting way better.

NECKSTRAP A ridiculous pain in the neck (sorry) to attach, a neckstrap is invaluable for keeping your rig at the ready. If you're a viewfinder shooter, adjust the strap so that the camera hangs right around your sternum, or a little lower. If you compose on the LCD monitor, have the camera hang slightly above your waist to allow a belly brace. Do not hang the camera from your shoulder; it's an invitation to camera drops and grab-and-run theft.

DATE AND TIME If your camera is fresh out of the box, it will prompt you to enter the date and

time. It's another pain in the neck but one that's definitely worth the effort, because this info will be stored with every picture you take and possibly help you organize your images (see #013). If you didn't do it before, do it now.

PROTECTIVE LENS FILTER While a lens hood offers the best protection for your front element, a clear protective filter can add another level of security for your glass.

LENS CAP Yes, you're going to lose it. Good riddance. You can't take pictures with a lens cap on. But a cap is imperative when storing a lens, so if you lose one, buy a cheap generic replacement—it's just as good as the original.

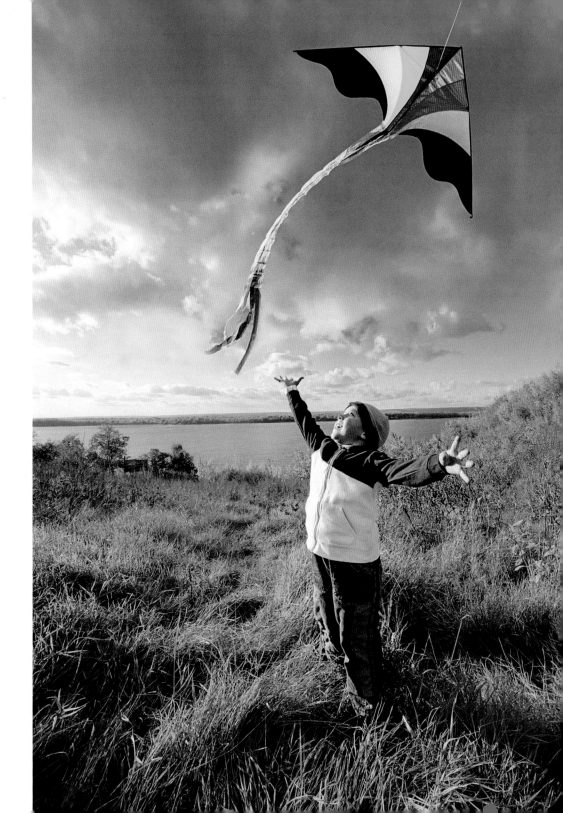

011 GO ON A PHOTO SCAVENGER HUNT

Okay, it's time. You've got your camera set up with a memory card, charged battery, properly attached lens, and that oh-so-stylish neckstrap. You've put it in P (for program mode), and witnessed firsthand how depressing the shutter halfway reveals all sorts of intel about your scene's light levels, as well as starts the focusing process.

You're now ready to take lots of pictures. The one rule is that there are no rules. Shoot lots; shoot everything. Over time, you will gravitate toward certain subjects and a visual style. But for now, you should be—for want of a better term—promiscuous. Here are a few ideas.

SHOOT WHERE YOU ARE—RIGHT NOW

Photograph every room in your house or apartment. Take an establishing shot at a wide angle from every side and corner of each room. Then use the zoom to photograph smaller details: decorations, odds and ends, last night's pizza box. Make it a multi-image portrait of your life. And now that you've done it, do it again in different light—in the evening, say, with the lamps turned up.

TAKE A COLLECTION Assemble some favorite objects, such as coins, tools, glassware, jewelry, or the charming array of marbles you see at right. Start shooting them with window light—first the direct light of sunlight, then the more diffuse light of open sky. Try rearranging the objects with an eye to how they catch, reflect, or transmit the light, too.

CHASE DOWN FRIENDS AND FAMILY Your friends and loved ones are (usually) willing subjects. Keep your camera at the ready for candids in the ordinary light of a yard, living room, or street corner. The more you do this, the less attention they will pay to you, which is a good thing. Take shots of acquaintances doing woodworking, needlepoint, or bicycle repair in their natural habitat—zoom or step back to take in the entire background. For kids or pets horsing around in the grass, try getting down on their level to find a fresh angle.

GO ON A WANDER Explore a neighborhood, woodland, or beach near you. Take shots at various focal lengths and distances. If you went on a sunny day, go on a gray one later—this light tames harsh shadows and is great for photographing people. Or do battle with your internal clock and head out very early in the day or late in the afternoon. Whatever your creative instinct urges you to do—just get out there and make shooting second nature.

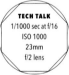

TECH TALK
1/1000 sec at f/16
ISO 1000
23mm
f/2 lens

012 GIVE THE FLASH A GO

If you've set your camera to P, the decision to use the built-in flash is up to you. While most photos don't benefit much from the weaker light of the on-camera flash, it helps to deploy the flash for some added light if you're getting blurry photos in low light indoors. (On some cameras, you just lift up the flash; on others, you press a button or slide a switch.) In P mode, the camera will balance the ambient exposure with the flash exposure for a reasonably natural look, but be aware that it will still have that flat flash look. Another good time to use it? Try the flash outdoors in daylight, too, if you're getting harsh facial shadows in a portrait. See #071–075 for more information on your built-in flash, and then check out #139–149 for what you can do with an accessory flash unit.

013 UPLOAD AND ORGANIZE

Whether you spent a long day shooting or just a fun half hour, you should always upload your pictures to a computer or tablet for viewing, editing, and storage as soon as possible.

First, this crucial step will allow you to delete images from your memory cards, which frees up space for more shooting. The best way to delete images? Return the card to the camera and reformat it—this will wipe it clean and prevent corruption. Second, it's always best to view images big on a monitor, not on your camera's small LCD, before making image selections. Transferring your images is also the first step to improving them with editing software (see #165).

So now is the time to get organized. Whether Mac, PC, or tablet, your device will recognize the photos and prompt you to upload them when you insert your memory card. Take it a step further and create multiple folders to organize your shots. Many people like to organize photos by date, others by subject, others by place. Various photo-editing programs have apps for organizing and filing, and allow you to tag photos with specific info. And please, always create an Untouchables folder for your originals.

See the Light

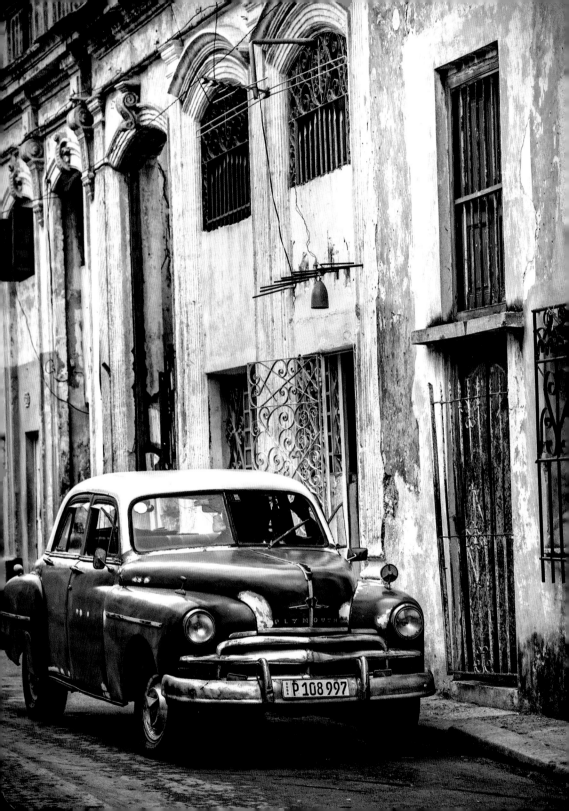

EXPOSURE

A digital camera is just a box with a hole on one side and a light-sensitive sensor on the other. To take a picture, the sensor needs just the right amount of light. If it doesn't get enough, details will vanish in darkness (*underexposure*). But if it gets too much, details will disappear in the highlights (*overexposure*). The correct *exposure*—determined by the size of the hole (*aperture*), the length of time it's open (*shutter speed*), and the light-sensitivity level (*ISO*)—will give you the best balance of highlights and shadows, with plenty of detail. In this section, we'll explore how your camera arrives at an exposure for a scene, and how you can set it up for success in program (P) mode. Later, in #067, I'll walk you through setting manual exposures, which will give you even greater control.

014 LOOK AT A GRAPH OF YOUR EXPOSURE

An excellent tool for evaluating your exposures is the *histogram*, a graph of the range of tones in the scene from darkest (left) to brightest (right). You can look at a photo's histogram post-capture on the LCD screen, or keep the histogram live as you shoot. In general, you want to see an even distribution from right to left, with a gentle peak near the middle. If you see the graph bunched up against the left or right side, you're getting *clipping*: shadow or highlight tones that are too extreme to be recorded by the sensor. And in many cases that's fine: The histogram for this classic car in Cuba, for example, reveals some detail lost in the car's shadow, as well as clipped highlights in the building's facade—both of which are acceptable. The trick is knowing when clipping is okay given your scene or vision.

TECH TALK
1/1250 sec at f/5.6
ISO 800
28–300mm
f/3.5 lens

Well exposed

Underexposed

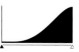
Overexposed

015 FILL THE LIGHT BUCKET

Exposure is the most crucial aspect of photography—in fact, taking a picture is often called "making an exposure." So let's slow this concept down and introduce a helpful if somewhat imaginative metaphor: filling a bucket with light. (Stay with me.)

Think back on a time when you filled a bucket with water. If you turned on the tap just a little, it took a good amount of time for the bucket to reach full capacity—say, 4 minutes. But when you started with the faucet opened twice as wide, your bucket filled up much faster, maybe in 2 minutes. And if you opened it up to its widest, that bucket may have been overflowing in only 1 minute. The fill level—exposure—is measured by a factor called *stops*. If you double the exposure, it's called adding one stop. If you halve the exposure, you're subtracting one stop.

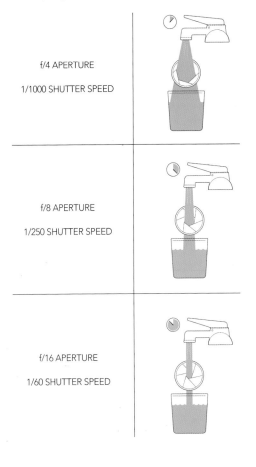

f/4 APERTURE

1/1000 SHUTTER SPEED

f/8 APERTURE

1/250 SHUTTER SPEED

f/16 APERTURE

1/60 SHUTTER SPEED

It's the same with your camera, only your camera's digital sensor is the bucket; the width of the faucet's opening is the lens's aperture; and the length of time that the water runs is the shutter speed. To ensure that the sensor receives just the right amount of light to make an exposure, you adjust the size of the faucet opening (aperture) and the amount of time you're letting the light through it (shutter speed).

Too little or too much of either shutter time or aperture width and you'll get photographs that are too dark (when the bucket didn't fill up all the way) or too light (when the bucket overflowed).

With some exceptions, the aperture and shutter are mechanical controls: When you push the shutter button to take a photo, a superaccurate timer tells the shutter curtain when to snap open and closed, while a variable circular opening called the *diaphragm* manages the width of the aperture. To see how these mechanics can be manipulated for creative effects, see #039–048 and #049–054, respectively.

TECH TALK
68 sec at f/13
ISO 100
14–24mm
f/2.8 lens

016 DISCOVER LIGHT METERING

How does your camera know just how to adjust your aperture and shutter speed to arrive at a quality exposure? By way of a *light meter*—an electronic device that measures the amount of light coming through the lens and creates an exposure setting for a *middle tone*. This calculation is based on the tone of an *18-percent-reflectance neutral-gray card*—in fact, it is common procedure to place one of these cards in your scene and take a meter reading directly off it. (It also can help with white balance, which we discuss in #060).

Your light meter's fondness for midtones creates even exposures, but it can cause problems. If you meter off a light-skinned person's face, for example, that exposure will render the person's face a middle tone. Meter off a dark-complected person's face, and the reading will also render the face a middle tone. Experienced photographers learn to adjust their exposures, but this doesn't lend itself to speedy automation.

The light meter in your camera, however, is smart. It can analyze scenes with complex lighting and make good guesses at the exposure. But it can still make a bad guess—or a good guess that you plain don't like. That's what exposure compensation (see #020) and manual exposure (#066–070) are for.

CONTROL CORNER
FIND YOUR METER MODE

Physical switch Very common on many cameras (almost always on the back, near your thumb), this switch lets you click quickly from mode to mode.

Physical button You press a button or a four-way controller, then twirl a command wheel to set your desired meter pattern.

Function menu/touchscreen menu Hit a button to go into an on-screen menu, then scroll with a command wheel or four-way controller (conventional menu) or finger-scroll (touchscreen) to access the meter choices.

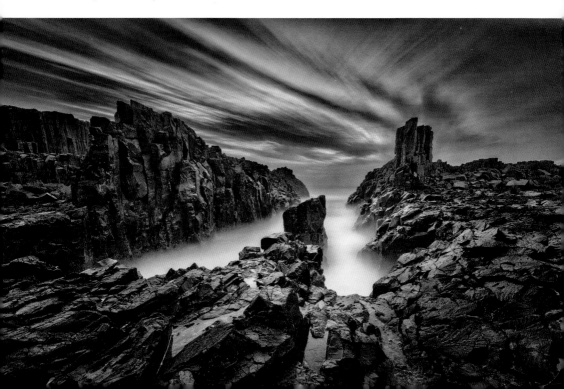

017 KNOW YOUR CAMERA'S LIGHT METERING MODES

Your DSLR or ILC camera has three, and possibly four, metering modes that allow your camera to arrive at its best guess of an exposure. Each metering mode uses a different tactic to measure the light in your scene.

SPOTMETER This metering mode measures the light in only a small circle delineated in the viewfinder or LCD. Strictly a reading for achieving a middle tone, the spotmeter is the preferred tool of very careful shooters looking to make precise exposures. Typical targets for a middle tone include gray rocks, green grass, and clear north sky midmorning or midafternoon.

LIMITED AREA This mode isn't found on all cameras; it behaves much like the spotmeter but takes in a wider area, and is hence also called *fat spot*. It's good for a quick reading of an important area of the scene that you judge to be more or less around that middle zone.

CENTERWEIGHTED This mode makes a reading over the entire area of the frame with a bias toward the center, and it averages its reading for a middle-tone setting. Long popular with many shooters, it is generally reliable, but it can be fooled—notably by strong backlighting or spotlighting in a dark surround. In the picture of the Quadracci Pavilion at the Milwaukee Museum of Art seen here, the photographer exploited this tendency of centerweighted metering by aiming his camera up and locking in an exposure for all the bright light coming through the windows. This produced a silhouette of the museumgoers. A spotmeter can also be used for this technique

EVALUATIVE Also known as multipattern, evaluative mode reads the light across multiple points—sometimes literally thousands—and analyzes it in software to arrive at a best guess. Many systems have built-in databases of sample scenes to compare with your shot. It also works with autofocus to sense the distance of objects in the frame and to bias the exposure to closer objects. This meter is your best bet for a wide range of shooting—it was used to create the foggy, all-over-gray cliffscape on the previous page (see #016).

RULE OF THUMB

018 SKIP METERING WITH THE SUNNY F/16 RULE

You don't need a light meter (either in-camera or handheld) to arrive at a pretty accurate daytime exposure. And no, it doesn't involve tedious, time-consuming trial and error.

It's a time-honored method called the Sunny f/16 Rule. Start by taking your ISO setting, and flip that number over into a fraction; for example, ISO 200 gets inverted to 1/200. Set that fraction as your shutter speed, then adjust aperture according to the lighting conditions at right.

Lighting	Aperture
Bright, sunny, blue sky	f/16
Hazy bright (distinct shadows)	f/11
Moderate overcast (soft shadows)	f/8
Heavy overcast (no shadows)	f/5.6
Open shade on a sunny day	f/4

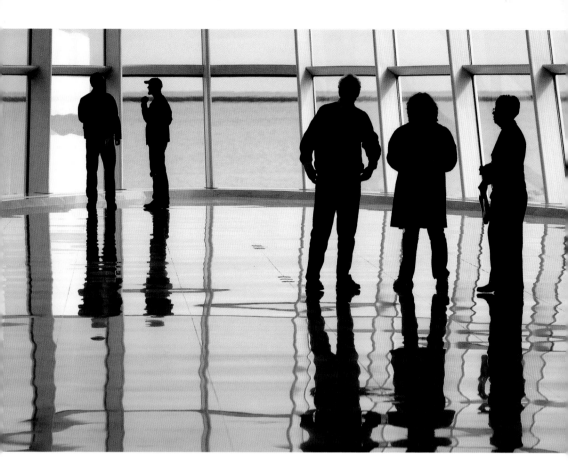

TECH TALK
1/1600 sec at f/4.5
ISO 200
135mm
f/2 lens

019
METER MANUALLY WITH AEL

One problem with autoexposure is that it locks on an area in the scene when you half-press your shutter button. But what if you want to meter a different area, but don't want to fuss with manual exposure? *Autoexposure lock* (AEL) to the rescue.

On the vast majority of cameras, AEL is found on a back button convenient to your thumb. To use it, simply aim the camera where you want to meter in your scene and press AEL. The exposure is locked there, freeing you to recompose the shot but keep the exposure. This function is especially useful for spotmetering—landscape shooters, for example, know that many rocks are neutral gray, and so they will lock a spotmeter reading off a rock and recompose for the actual shot.

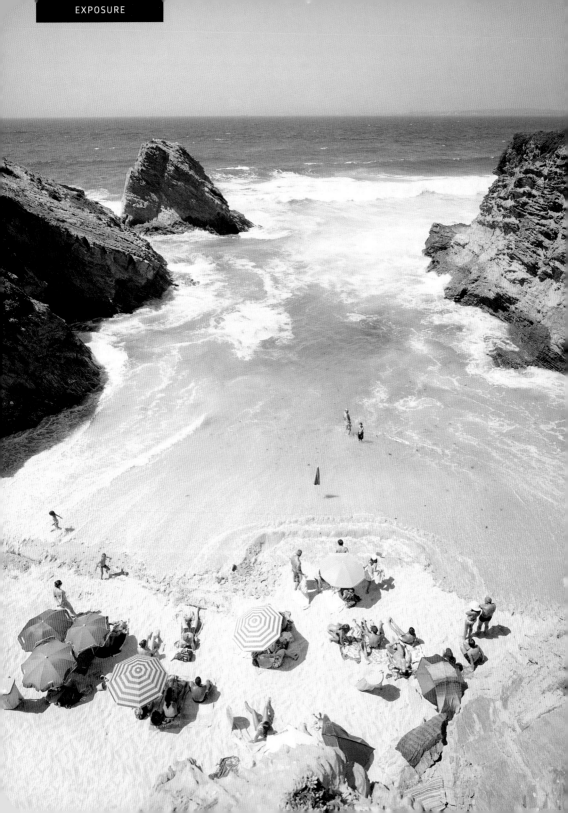

020 FIX EXPOSURE PROBLEMS WITH EXPOSURE COMPENSATION

Here we come to a really important concept: There is no such thing as an objectively "correct" exposure. Sure, grievous mistakes—gross underexposure or overexposure resulting in total loss of detail—are bad exposures. But if, in your mind's eye, you see a landscape, portrait, still life, or any kind of picture as lighter or darker than reality, go for it. And here's how: It's called *exposure compensation* (EC).

Your camera might have an actual EC dial, but with most cameras, you access EC via a button with the universal +/- symbol, and then twirl a dial or wheel to make the setting. It's about as intuitive as it can get. If you dial EC in the positive (+) direction, you'll make the picture lighter. Dial it to negative (–), and the picture will be darker. The EC scale is laid out like a ruler, and the standard big gradation is one exposure value (EV), usually called a stop. EVs are very precise steps: Increase by one EV (+1.0 EV), and you double the exposure; decrease by one EV (–1.0 EV) and you halve the exposure. You can dial in lightening or darkening by one-third increments as well. At right are some situations in which EC can really come to the rescue.

STRONG BACKLIGHTING When working in intense backlight, a portrait subject might be a near-silhouette, even with the best efforts of "smart" metering (see #017). Crank up the exposure by at least +1.0 EV.

AREAS OF BRIGHT WHITE Pale sandy beaches in bright light, like the one at left, don't always keep their crisp whiteness. Some smart meters may catch them, but often these scenes will end up gray. Dial up EC by at least +1.0 EV; you may need up to +2.0 EV.

SPOTLIT SUBJECTS Let's say you're trying to photograph performers onstage. The meter may see all that black background and overexpose badly. To fix, take EC down by at least –1.0 EV.

021 SEND ISO TO THE RESCUE

Shutter and aperture have a third partner in exposure control, called ISO (see #055–058 for more information on this function). ISO is a purely electronic setting that can boost the signal from the image sensor. It has no influence over the amount of light the bucket—oops, image sensor—receives. It is simply a sort of cheater switch that allows the camera to deal with too little or too much light.

If up until now you've been shooting on all-auto or a scene mode, the camera has been setting the ISO automatically. But many models put a limit on how high the ISO can go in these modes. And if you've been shooting in P mode at ISO 800 (as I recommended in the Photo Primer

section), you may have run into situations where you're just not getting the picture you wanted.

So next time, turn up the ISO if there is too little light for your desired exposure setting, or turn down the ISO if there is too much. And in casual situations where you just need a quick pop of light, leave ISO where it is and turn on the built-in flash (see #071–075).

TECH TALK
1/125 sec at f/16
160 color negative film
65mm
f/5.6 lens

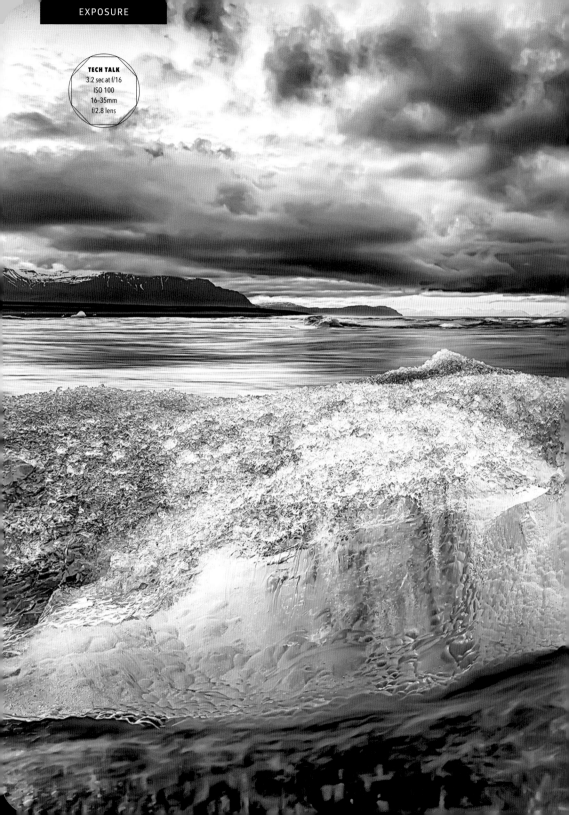

TECH TALK
3.2 sec at f/16
ISO 100
16–35mm
f/2.8 lens

022 BRACKET TO ENSURE GOOD EXPOSURE

Bracketing dates way back to the film era, when photographers learned to nail exposure by shooting one image at the meter reading, then two more—one a bit above and one a bit below. Luckily, this procedure is now automated, and it lets you quickly test out a few different exposures. You can set the intervals of your brackets (a third stop, a half stop, etc.) and how many you want to take. Then, when you press the shutter button, the camera takes all the exposures in a quick burst. Bracketing is especially useful in scenes with rapidly changing light—for example, it helped Lewis Abulafia perfectly expose this landscape's moody blues as a chunk of ice calved from an iceberg at dawn.

LIGHT

Experienced photographers talk differently than snapshooters do. A snapshooter might look at a scene and say, "That would make a great picture!" But an experienced shooter looks around and says, "Wow, look at that light!" If you took lots of shots on your photo scavenger hunt (see #011), you probably noticed how the quality of light can change the look of things dramatically. That landmark old house? In angular, direct light, its architectural bones and ornamental detail come sharply to the fore. In mist, a sense of a bygone era—maybe even melancholy—dominates. Your portraits of a male friend? Lit by crisp afternoon sidelight, he may look like a craggy man of action, despite the grin. In overcast lighting, that same grin adorns an open, kind face. That's the power of light: It not only changes the look of your pictures but their emotional impact as well. Learn light and you've learned photography—the rest is technicalities.

023 GO WITH HARD OR SOFT ILLUMINATION

The softness and hardness of light is determined by the extent of *diffusion*: the scattering of light. Light whose rays go every which way fills in harsh shadows, suppresses texture, and lowers contrast. Light whose rays are direct (i.e., parallel or nearly so) deepens shadows, accentuates texture, and increases contrast. You can manipulate the effects with simple placement.

GO BROAD OR NARROW The broader the light source, the softer the light. The narrower the source, the harder the light. Makes sense, when you think about it: A wide light source disperses rays across your subject, while the narrow source sends more direct, parallel rays.

GET CLOSE—OR FAR Meanwhile, the closer the light source, the softer the light. The farther the light source, the harder the light. Prime example? The sun, which is so far away that it's just a small ball in the sky, and its direct rays hit us parallel, making for very harsh light.

024 WIELD WINDOW LIGHT

Soft light shines the most in portraits—especially those set by a window so that indirect light bathes the subject in a gentle glow, like the one at left. Shoot by a north-facing window or under an overcast sky, and play with your subject's distance and angle from the window until soft light, without harsh highlights or shadows, falls on her face. With your model sidelit by the window, try a few shots with her facing you, then ask her to rotate three-quarters, and then to a profile, facing the window. A wide aperture (see #049) will blur the background, highlighting the illuminated face.

025 OPT FOR DIFFUSED LIGHT

Many photographers like the look of soft, diffused light—generally, it creates a flat, even illumination that saves your subjects from the harsh shadows and distracting glare of undiffused light. Here's how to get it.

GO NATURAL Believe it or not, overcast skies can be your friend. When clouds drift in front of the sun, they act as nature's softbox (see #154): The shadows get less distinct, as in the image below. Add fog, and watch those shadows disappear.

SEEK THE SHADE Even on a brilliant, cloudless, blue-sky day, you can escape harsh light by simply going under the shade of a tree or into the shadow of a structure. There will be plenty of soft light for a correct exposure. One caveat: Open shade can be quite blue in color. See #060–065 for ways to control white balance.

BRIM WITH CONFIDENCE A quick and fun fix for a portrait under harsh overhead sunlight is a broad-brimmed hat. Make sure your subject's face is fully in the shadow of the brim, and meter off the face to avoid underexposure. It works well at the beach, where sand can reflect light and open up shadows.

TRY BACKLIGHTING Few subjects are totally backlit—that is, with no light at all falling on them from the front. Someone standing outside with her back to bright sunlight will have light falling on her from the open sky in front of her—and it will be quite soft light at that. The trick is to get your exposure right—see #020 for tips.

TECH TALK
1/320 sec at f/2
ISO 320
35mm
f/1.4 lens

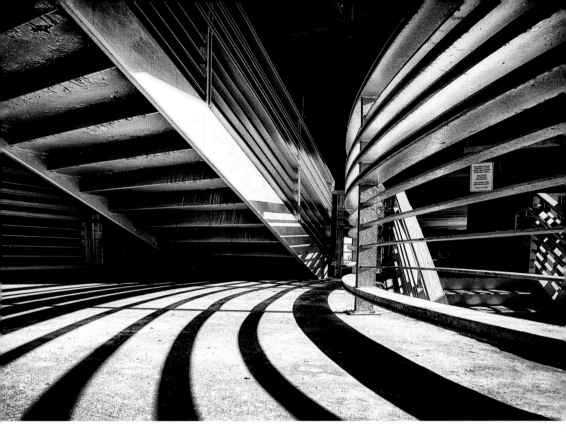

026

EMBRACE HARSH LIGHT

By now you may be thinking that I value soft, diffused light above all others for photography. Not so! Hard light can be very effective for defining shapes and textures, particularly in architectural photographs, shots of craggy landforms and gnarly plant life, and even portraiture—think edgy character studies of weathered faces.

High-contrast light is also very effective in patterns of shadows, as in the photo above, which shows both the shadows and the objects casting the shadows forming leading curves into the composition (see #104 for more tips on dynamic lines). Exposure under hard light is trickier than under forgiving soft light; it's very easy for highlights or shadows (or both) to end up clipped—devoid of detail. To expose scenes like this, try evaluative metering first. Check the histogram and highlight/shadow warnings to see where you may be losing detail. Use exposure compensation (see #020) to tone down the highlights or bring up shadow detail, as you see fit. In these situations it is often best to follow this rule: Let the shadows fall where they may—that is, adjust the exposure so that it just hangs on to highlight detail while sacrificing deep shadow detail.

TECH TALK
1/125 sec at f/11
ISO 100
14mm
f/2.8 lens

027 MAKE LIGHT THE STAR OF YOUR SHOT

The real medium of photography is neither a digital sensor nor film but light—it's light that defines the objects of the world, and it's the stuff that we use to "paint" those objects with a camera. But light itself can serve as the subject in a photo (either in a starring role or as a supporting actor) in landscapes, architecture, or portraiture. Here are some performances that can be award winners.

"GOD RAYS" Technically called *crepuscular rays*, these familiar shafts of light radiate out of holes in clouds (as in the picture below), between the valleys in a mountain pass, and through windows. They form as clouds are dissipating, so keep your eyes peeled in this situation. A similar phenomenon occurs in dark, cavernous interiors, such as cathedrals and grand old train stations.

DIFFRACTION STARS Shooting directly into a strong point light source (like theater spotlights or the sun on the horizon) at very small apertures such as f/16 (see #018) will create multipointed "stars." The number of points will equal the number of blades in your lens's diaphragm.

LENS FLARE The distracting veil that obscures edges, smothers contrast, and fogs detail has often been viewed as a boo-boo, but it can also add mystery to portraits, interior shots, still lifes, and even nature scenes. Flare results when strong light enters the lens directly (as in backlight) and produces unwanted reflections within the lens. Modern lenses have such effective antireflection coatings, though, that it's difficult to get flare with them, and so some specialty lensmakers are producing—yep—flare-prone optics.

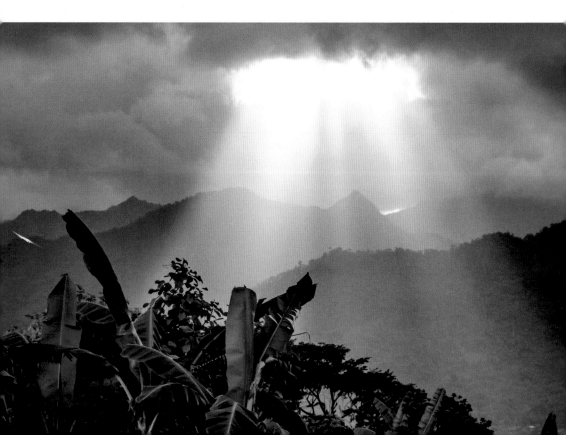

028 CHANGE LIGHT BY CHANGING DIRECTION

The direction of light on your subject profoundly influences the look of your photos—and their emotional impact. And like diffusion, direction may be a natural constraint that you have to work with or a factor that you can control completely.

LIGHT FROM THE FRONT Front lighting evens out shadows and flattens: By filling in nooks and crannies, it makes photos look two-dimensional instead of three-dimensional. This isn't necessarily a bad thing—front lighting for portraits can help mask wrinkles, especially if the light source is also diffused.

GO LOW OR HIGH Front lighting from above or below creates dimensionality and texture by adding shadows—which, in photographic lingo, produce volume, the sense that a scene is really three-dimensional, as in this image. One famous method is *Hollywood lighting*: direct front lighting, from up high. It produces that all-important nose shadow halfway down toward the upper lip.

MOVE IT OFFSIDE Sidelighting is drama distilled: By emphasizing shadows, it increases dimensionality, particularly in the light of early morning or late afternoon. Thus, it's a favorite of landscape shooters. It often works great for portraits, too.

LIGHT FROM BEHIND Backlight is a smart shooter's secret weapon. So often disdained for its role in difficult exposures and lens flare, it can produce stunning effects. Just don't expect dimensionality—it works by flattening. With a

portrait, it can smooth skin; outline hair with illumination (called *rim light*); and create a bright background that suppresses unwanted detail. That rim light trick comes in handy when capturing the texture of furry animals or making an old building look majestic. And don't forget flowers: Backlight on translucent blooms can highlight their fragile tissue.

> **TECH TALK**
> 1/1000 sec at f/5.6
> ISO 500
> 24–70mm
> f/2.8 lens

RULE OF THUMB

029 BAG THAT BEAUTIFUL BLUE SKY LIGHT

One type of natural light combines diffusion with a hard edge in an extraordinary way: the light of open blue sky opposite the sun's position. This is called *north light* (or *south light*, if you're down under), and innumerable photo studios have been built with windows to face it: a broad, even expanse of illumination, but it's also clear, which allows for shadows and saturates colors in a way that's . . . indescribable. It's good for everything—but particularly portraits and landscapes.

ONE SCENE, FOUR WAYS

030
MAKE A FOREST OF ONE TREE – WITH LIGHT

Here's a challenge for you to explore all the ways in which light alone can alter the image of a single object. Find a handsome tree near you and take at least four pictures of it—each in different lighting. The only rule: Keep the tree the same size in the frame.

Feel free to walk around it for different angles at the same time of day—capturing it in front light, sidelight, and backlight—and to shoot it at different times of day, and on days with different weather. It's helpful to dedicate a memory card to this project so you can keep the shots all in one place.

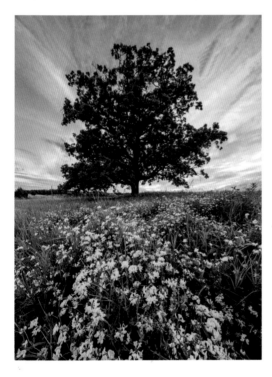

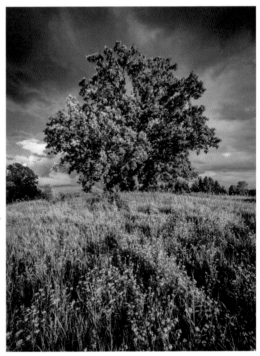

SUNSET, BACKLIT What could be a better backdrop for your tree than a sunset? Besides the beautiful backdrop, the setting sun also casts low, warm light that can provide soft fill for the foreground. Note the different hues and the shape of the tree's shadow as you shoot–and shoot lots, as this light is fleeting.

GOLDEN HOUR, SIDELIT Photographers have dubbed the period an hour before sunset or after sunrise the *golden hour*, largely because the sun's low rays create a remarkably beautiful warm, soft, and low-angle light. Try positioning yourself so the tree is lit from the side to experience how the rays pierce through the foliage.

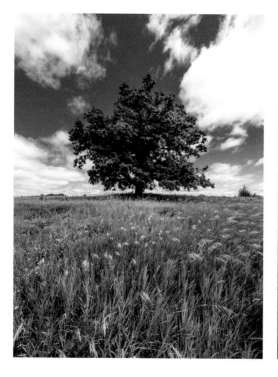

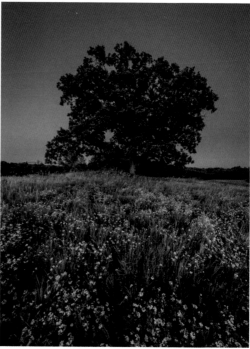

HIGH NOON, FRONTLIT While it's usually considered a no-no to shoot in the overhead light of midday, trees are photogenic enough that the harsh shadows they cast create visual interest (instead of unflattering areas of high-contrast shadow and light).

BLUE HOUR, BACKLIT After the golden hour comes another magical photo-making time of day: the *blue hour* (or *l'heure bleue*, since everything sounds better in French), when the sky turns a dark, rich cobalt. Try shooting your tree as a dark silhouette in front of the inky blueness for lovely contrast.

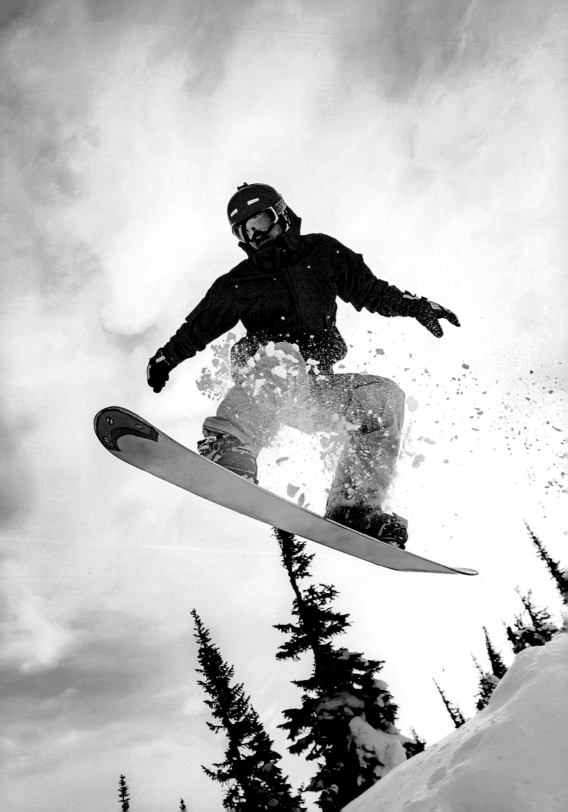

FOCUS

When you half-press the shutter button of your camera, technological wizardry springs instantly to life in a feat called *autofocus*: The camera focuses the lens by itself, moving the lens barrel or elements within the lens to make your subject sharp, all the while displaying your focus points with one or several red dots (depending on your autofocus mode). Because we humans are endowed with eyes that autofocus on their own (sometimes with the aid of corrective lenses), you might take camera autofocus (AF) for granted. But you shouldn't—you should make AF your obedient servant. You can instruct it to take full control, exert considerable control over the AF yourself, or bypass AF entirely by switching to manual focus (see #037). The two major AF controls govern how the focusing is done and where in the frame it takes place. Let's see how they team up to bring the world sharply into view.

031 CONTROL THE *HOW* OF AUTOFOCUS

Autofocus modes essentially determine whether the autofocus locks the focus on the original position of your subject, or lets the focus roam with your subject.

SINGLE-SHOT This mode is usually designated with an S. Once the AF achieves focus, single-shot mode will lock it there as long as you maintain the half-press on the shutter, and it won't let go until you take the picture. Your subject can move, or you can recompose the shot, but the original focusing point will stay put. And if the AF can't find focus, you can't take the picture—press the shutter as much as you want, but no go. A focus-confirmation lamp (almost always a green LED) will glow steadily when you've locked focus. (You will also get a beep, which you can turn off.)

CONTINUOUS To focus on moving subjects such as the snowboarder at left, using continuous mode (C) is a good tactic. It will focus with a half-press of the shutter, but it doesn't lock on. If your subject moves, or if you re-aim the camera, the AF will continuously attempt to refocus on the subject. You can fire the shutter at any time, regardless of whether the subject is in focus or not. Continuous is often used with burst-exposure mode, for rapid-fire shot sequences (see #113).

AUTOSWITCH This mode starts out as single-shot, but if subject motion is detected, it will switch to continuous. Depending on the camera model, it can go by various designations, sometimes simply A.

CONTROL CORNER
FIND YOUR FOCUS

Switch On the lens or near the lensmount. Lets you select single or continuous AF, or manual focus (MF).

Menu Select an AF mode from a menu brought up by a control panel button.

Four-way controller Serves as the selector switch for AF area.

Touchscreen Activate AF areas by touching them.

032 CONTROL THE *WHERE* OF AUTOFOCUS

These modes regulate where in the picture frame your camera's autofocus will look for focus. All current and recent cameras have multiple AF points arranged across the frame; some have hundreds of points covering virtually the entire frame. According to the camera make and model, you can select the focus point with a joystick-type controller, a four-way control pad on the back of the camera, or a touchscreen, in conjunction with menu commands.

CENTER POINT This is the classic, favored by many for simplicity and reliability. It employs the central autofocus point only, which is almost always the most sensitive one available.

WIDE AREA This works much like center point, except it employs several sensors to the left and right of the middle to catch subjects that aren't quite centered—good for less-predictable situations.

MULTIPLE POINT, USER-SELECT This type of autofocus lets you specify the AF point at which you want to focus, which is useful for off-center subjects if you don't want to continually refocus and recompose your image.

MULTIPLE POINT, AUTO-SELECT Here, the camera runs on AF autopilot, selecting an AF point according to its own programming. It usually biases the AF point toward the center and/or the closest subject in the frame. Try it for tracking action.

MULTIPLE GROUP, USER- OR AUTO-SELECT Why go with one when you can choose a cluster of AF points? It's great for tracking erratic motion or for scenes with complex patterns, but it's not present on all cameras.

> **TECH TALK**
> 1/500 sec at f/4
> ISO 400
> 16–35mm
> f/4 lens

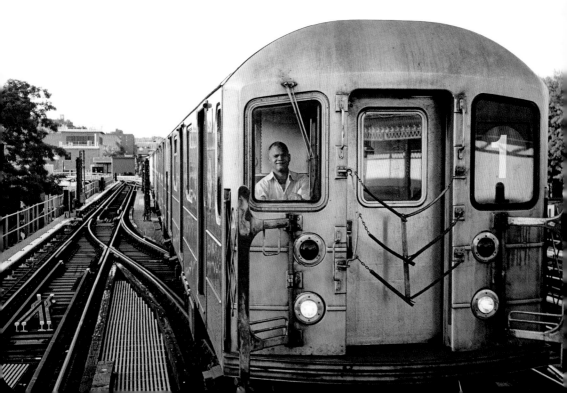

033 COMBINE AF MODES TO GET YOUR SHOT

Different shooting situations lend themselves to different combinations of the two major AF controls. This is by no means an exhaustive list but a jumping-off point for common AF setups that might help you out.

SINGLE-SHOT AF, CENTER POINT Aim, lock the focus, recompose if necessary, and shoot. This combo works much like fast manual focusing (see #037); it's good for candids, scenics, portraits—almost any situation with little or no subject movement. It's also handy for prefocusing action shots: If you know the play is likely to be at second base, lock focus on the bag and wait for the slide.

SINGLE-SHOT AF, USER-SELECT You compose first, then move the AF point where you want it in the frame. This tactic is helpful in relatively static situations where you want to maintain off-center focusing—a portrait or a scenic where you want the focus maintained on an element off to the side of the frame. It's also a good bet for prefocusing action shots.

CONTINUOUS AF, USER-SELECT Pick an AF point (or group) in the frame that you plan to keep on your subject, and re-aim as necessary when the subject moves. Try this method for subjects that might be still one moment and then suddenly moving the next—kids, cats, dogs, and so on. It's also good for tracking motion at a fairly predictable area of the frame. Take, for example, the photo of the subway train you see here, in which the photographer selected an AF point to the side of the frame and let continuous AF track the train.

CONTINUOUS AF, AUTO-SELECT This mode allows you to follow the action as much as you can and hope for the best. It's good for chaos: kids running in the yard or sports like soccer or hockey. It's also good for tracking subjects moving rapidly across the frame—such as flying birds or running wildlife.

034 DEPLOY AF ASSIST

Most all cameras have an AF-assist beam, which casts a white or red light on your subject to help the autofocus "see" in situations where the light is too low for reliable autofocus. Most also cast a pattern to help focus on low-contrast subjects. These beams have a limited range and can be quite obtrusive for human subjects. The beam can be shut off in the camera's setup menu.

035 FOCUS WITH YOUR THUMB

You don't have to use the half-press on the shutter button to trigger autofocus. You can usually use the setup menu to relegate focus to a button on the back of the camera. By doing this, you can aim the camera at your desired focus point, lock it with a thumb press on the button, and re-aim the camera. In common parlance, the reassigned switch is called the *back focus button*.

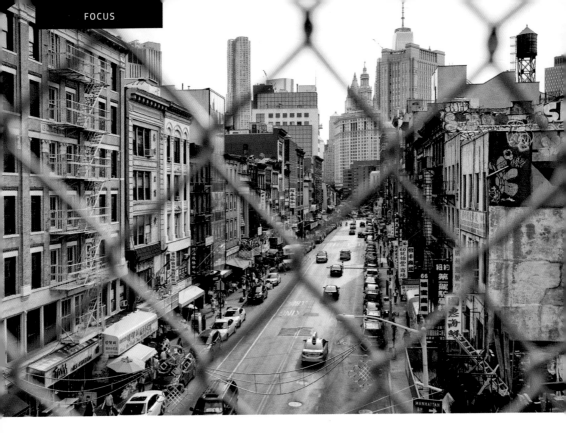

036
UNDERSTAND WHY AUTOFOCUS GOOFS (OR QUITS OUTRIGHT)

As good as current autofocus is—and it's very, very good—there will be situations when it punks out on you. Here are some typical AF-fail scenarios.

LOW LIGHT AF gets sluggish in the dark, and it will, in very dim scenes, fail. Fixes to try: Turn up the lights if possible, or deploy the AF-assist beam to light up the scene. If those fail, engage the single—and strongest—central AF point, or opt for manual focus.

DIM LENS AF systems can slow to a crawl at small (i.e., dim) apertures—see #049–053. As a rule of thumb, a lens that can get no brighter than f/5.6 will be borderline for reliable AF performance, particularly when you're shooting in low light. For an easy fix, move to manual focus.

LOW-CONTRAST SUBJECTS Aim your camera at a blank wall or an empty expanse of blue sky—the AF simply has nothing to lock on, and your shutter button won't depress. Try using the AF-assist beam for relatively close subjects, lock on an area of contrasty detail that's the same distance as your subject, and recompose, or switch to manual.

COMPETING SUBJECT MATTER A classic example: bars in front of a zoo cage or a fence in front of a cityscape, as above. The AF will focus on them instead of the scene you're trying to photograph. Move close enough to the bars to focus through them, or switch to manual focus.

037 GO TO MANUAL FOCUS WHEN NEEDED

With *manual focus* (MF), you cancel autofocus and become the focus controller yourself. Engaging MF is usually as simple as throwing the single-shot/continuous AF switch to M for manual. The bad news: Many lenses, particularly inexpensive ones like kit zooms, have clumsy manual focus—if they have it at all. The good news: Many (pricier) AF lenses have nice smooth manual focusing, which can sometimes be used as a focusing touch-up with the lens still set to AF.

There are a variety of reasons to go to manual focusing beyond when autofocus becomes difficult or outright impossible,

as described at left. You may also want to employ it in set-it-and-forget-it situations, like still lifes, carefully composed scenics, and studio setups where you set one focusing distance for many shots. It's also great for video: Even quiet autofocus can mar a video soundtrack, and AF can be too herky-jerky for smooth focusing transitions. Regardless of your rationale for turning off autofocus, here are some tips for making the most of manual.

RELY ON AF TOOLS The autofocus-confirmation lamp and the beep will still verify that you've manually focused at your chosen point.

MAGNIFY THE IMAGE In live view on your LCD screen or in an electronic viewfinder, you can go in close for fine focusing on a critical area in your scene. It's often done with a press of a button—look for one with a magnifying-glass icon on your camera body.

USE FAST MANUAL This is a favorite method for many photography enthusiasts. You simply use single-point autofocus to lock on to the exact focus point you want in your scene—then throw the AF mode switch to manual. You can now shoot away with the focusing point safely locked in place.

TRY THIS

038
OPT FOR TOTAL DEFOCUS

Perfect focus is always the goal—except when it's absolutely not. For a dreamlike photograph that hints at your subject but doesn't render it literally, try defocusing your lens. Just set your camera for manual focus, start with a sharp image in your viewfinder or LCD screen, and then slowly turn the focusing ring until everything's a lovely smear. When to stop? When the picture looks best to you—try it a few different ways until you like what you see.

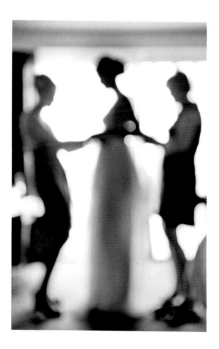

TECH TALK
1/250 sec at f/2.8
ISO 400
24–70mm
f/2.8 lens

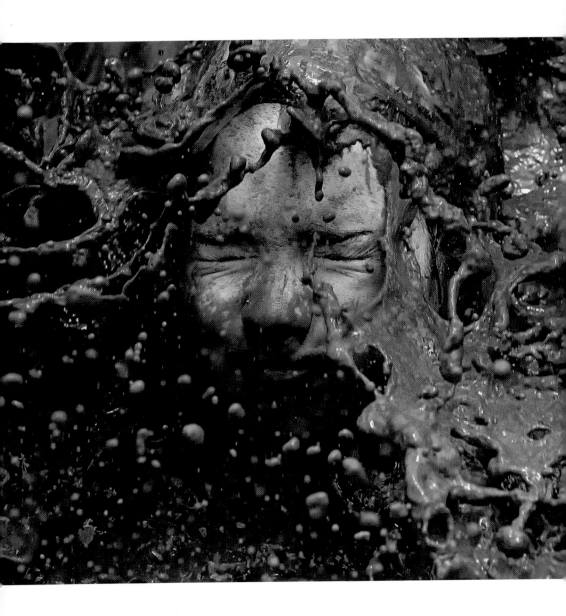

SHUTTER SPEED

The shutter in your camera is a complicated mechanism, but it does a very simple thing: controls the length of your exposure. It's basically a set of curtains in front of the imaging sensor. Press the shutter button, and one curtain opens to expose the sensor to light, and a second curtain then shuts to end the exposure. If the shutter stays open a long time, it lets in a lot of light; if it's open a short time, it lets in little light. The standard shutter timings are 1, 1/2, 1/4, 1/8, 1/15, 1/30, 1/60, 1/125, 1/250, 1/500, 1/1000, 1/2000, 1/4000, and (on some cameras) 1/8000 sec. There are intermediate settings, too, and your camera most likely has slower speeds, down to 30 sec—or even longer.

Beyond helping you land on an ideal exposure (see #014–015), your choice of shutter speed also changes the look of your pictures—sometimes dramatically so. With fast shutter speeds, the camera captures a short slice of time, freezing subjects in action, while at slow shutter speeds, the camera documents a long slice of time, letting motion blur across the frame. Regardless of your subject, learning how to harness shutter speed is crucial to achieving your aesthetic vision.

CONTROL CORNER
FIND YOUR SHUTTER SPEED SETTING

Traditional dial Shutter speeds are in plain view on a dial.

Control wheel A control wheel on the front or back of the camera sets shutter speeds, which are displayed on a top-deck or back control panel.

Quick menu or touchscreen Bring up a menu on the rear LCD, and pick a shutter speed from a scale by way of a control wheel.

TECH TALK
1/1600 sec at f/9
ISO 1000
100–400mm
f/4.5 lens

TRY THIS

039 FREEZE MEGAFAST ACTION

You don't need specialized equipment or complex image editing to create "frozen" drama—just a camera, a lens that's long enough to get you out of the splash zone, a fast shutter speed, and a subject willing to get a face full of muck, as was this mud run participant. Use the harsh light of midday sun to sharply define the beads of liquid, and set your camera to one of the fastest shutter speeds—1/1000 to 1/8000—and adjust ISO high enough to give you sufficient exposure. Then position yourself close to the quagmire and shoot away. Below is a handy cheat sheet for shutter speeds and their effects.

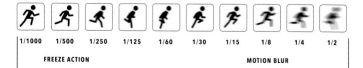

1/1000	1/500	1/250	1/125	1/60	1/30	1/15	1/8	1/4	1/2

FREEZE ACTION　　　　　　　　　　　　　　　**MOTION BLUR**

040
TAKE FULL CONTROL OF SHUTTER WITH S MODE

To command your camera to use a specific shutter speed without going full-on manual, use the exposure mode called *shutter-priority auto*. On most camera makes, this mode is denoted simply by S; on a few others, by Tv (for time value). You'll find the setting in the same place where you set P (see #003). Once in S mode, set the shutter speed that you want using the dial or touchscreen menu, and presto—the camera locks it there. Then, to maintain proper exposure, the camera will automatically adjust the other control—aperture. This way, there's one less thing to think about when shooting.

Don't worry if in some lighting conditions (mainly dim light), you get blinky warnings in the viewfinder. It just means that you've exceeded the range of apertures available for your chosen shutter speed. Fix this with flash or by bumping up your ISO (see #021).

041
STAY STEADY TO BAN THE BLUR

One problem with slow shutter speeds is . . . well, frankly, you. Even people with the steadiest hands can't hold a camera still enough for sharp shots at slow shutter speeds. And so, the photo of moving water you took handheld at 1 sec ends up being blurred overall—not the effect you wanted. This is where a steady camera support (read: tripod) comes in (see #116). With the camera on a tripod, your shot of moving water will show the silken stream running through a sharply rendered landscape.

Another shake-buster: Your camera or lens may have *image stabilization*, which can also help to steady a handheld shot at marginal shutter speeds, like 1/30 sec. Image stabilization works by shifting lens elements, or the image sensor itself, to compensate for hand shake. It's good for available-light candid shots and handholding a long lens (see #089). But for really long shutter speeds, it won't help. You need that tripod. And bear in mind that, the longer your lens or the closer your focus, the more it will magnify handheld shake.

TRY THIS

042 CHOOSE PLAN B FOR REALLY LONG EXPOSURES

If you want to make a really long exposure—say, 20 minutes, 2 hours, or more—try out the shutter-speed setting marked as B, for bulb. (It refers to cameras from a century ago that were fired by an air bulb, no kidding.) In this mode, your shutter will stay open as long as you keep the button depressed. (Another, slightly easier tactic is to invest in a remote cable release that you can lock and leave.)

Ultralong exposures are best known for images of star trails—those wonderful shots showing the stars streaking across the night sky. Meanwhile, ultralong exposures in daylight can blur people on the street or cars on the highway so they essentially disappear (see #047 and #138).

043 KEEP STARS FIXED WITH THE 600 RULE

With long exposures of a starlit sky, the Earth's rotation will blur stars into streaks—exactly the effect you want for star trails. But if you want to keep the stars more or less as sharp dots (as they appear above), you'll have to limit the time the shutter is open. For cameras with a full-frame sensor (see #076 for an explanation of various sensor sizes), follow the 600 Rule: Divide 600 by your chosen focal length to arrive at the longest time, in seconds, that you can keep the shutter open. For example, with a 50mm lens, 600 divided by 50 gives you a max shutter speed of 12 sec. For APS-C cameras, use a 400 Rule; for a Micro Four Thirds sensor, use the 300 Rule. The maximum timings are on the optimistic side and will allow for just a modest degree of image magnification. If you're looking to show your image as a big print or on a big screen, cut the shutter times even further to avoid telltale star smear.

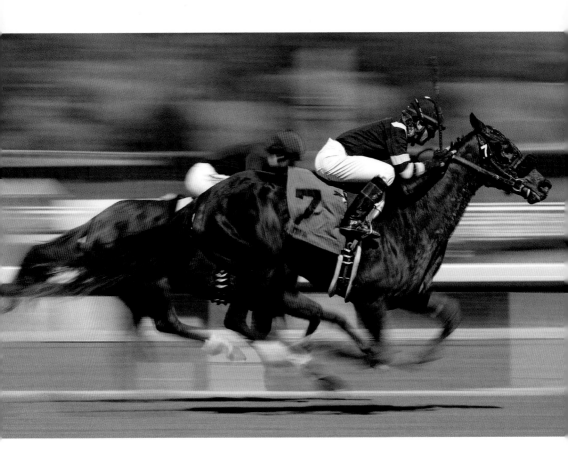

044
PAN AT SLOW SPEEDS FOR FAST ACTION

Deliberately moving the camera during a slow shutter speed may sound like a very bad way to catch action, but it's the basis for one of the most eye-grabbing ways to do so: *panning*. To try out this technique, choose a slow shutter speed (1/2 sec to 1/15 sec is a good starting range) and track the moving subject horizontally across the frame during your exposure. The motion of the camera will blur the background into a horizontal streak, while your subject will be sharp enough to still be recognizable. It takes practice—stand by the side of a busy road and pan passing cars to get your chops. The tactic works particularly well with bicyclists, fast cars, and galloping horses, like you see here.

A trick of the trade for you: If your camera or lens has image stabilization, check your manual to see if it has a setting for panning stabilization. This stabilizes the image in only the up-down axis to keep your pan looking level and not "bouncy."

TECH TALK
1/40 sec at f/8
ISO 100
70–200mm
f/2.8 lens

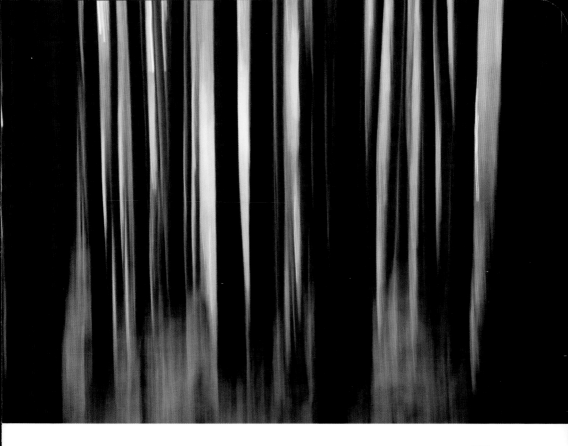

045 MAKE A BLURRY ABSTRACT

TECH TALK
1/3 sec at f/5.6
ISO 640
24-105mm
f/4 lens

Now that you've tried panning, you can cast off your blur worries and have fun moving your camera during a long exposure—even if your subject is staying put! Pick a scene with multiple colors: a woodland like the one above, park, street scene, or spot in your own home. Fire off exposures of 1, 2, or 4 sec while moving the camera. Linear motion will make streaks, circular movement will create swirls, and random motion will make for surprises.

QUICK TIP

046
MAKE SPEEDY PORTRAITS

Another great use for superfast shutter speeds? You may be astounded: quiet, static portraits in daylight. Say you want to take a portrait outside on a bright sunny day, with your lens set to f/2 in order to limit depth of field (see #049). Even at your camera's lowest ISO, you'll need a fast shutter speed along the lines of 1/6400 sec—and voilà, your camera has it!

047 SHOOT MOTION AT DIFFERENT SHUTTER SPEEDS

At first, blur in your photos of moving subjects can seem like a rookie mistake—you may instead aspire to perfectly frozen scenes with crisp details, achieved with fast shutter speeds of 1/500 sec or shorter. But slow shutter speeds can communicate motion and the passage of time to dazzling effect. By exposing the camera's sensor to light for a longer period, you can introduce atmospheric trails, streaks of color, and smeared backgrounds as your subject moves across the frame. Here are some examples and tips for boosting blur in your shots.

GO ON A STREAK Drop the shutter one or two stops below action-freezing speed to blur a sprinter. For a ghostly streak behind the subject, add flash and set it to second-curtain sync (see #146). **TECH TALK: 1/30 SEC AT F/22, ISO 100, 12-24MM F/4.5 LENS**

GUIDING LIGHTS Tracking a moving light source—such as a whirling carnival ride—during a long exposure can result in vivid streaks of light. Try this technique out at blue hour (the time just after sunset) to benefit from the warm yellow light contrasting against the rich cerulean of the sky. **TECH TALK: 5 SEC AT F/8, ISO 100, 38MM F/5.6 LENS**

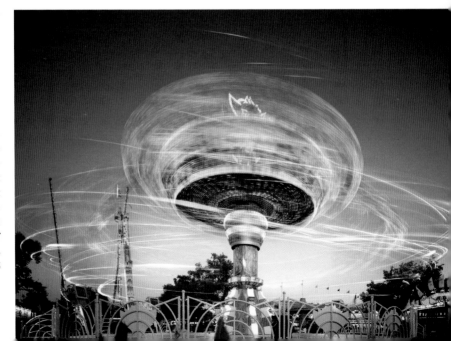

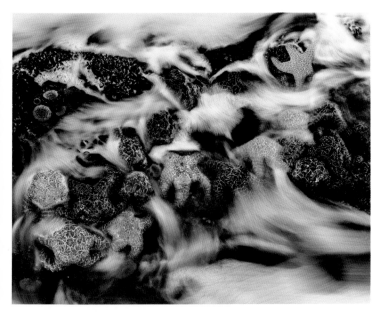

RAPID WATERS To blur water as it ebbs and flows between rocks and sea life (or even as it cascades over a cliffside), mount your camera on your tripod and set a shutter speed of between 1/2 and 5 sec or even longer, depending on the flow. **TECH TALK: 1/3 SEC AT F/11, ISO 100, 24-70MM F/2.8 LENS**

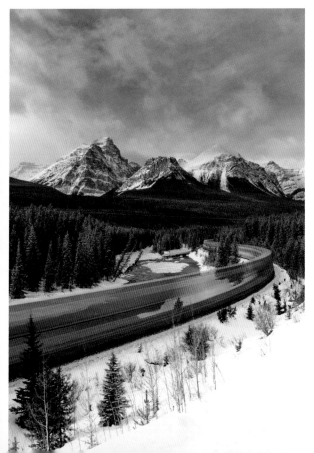

RUNAWAY TRAIN To blend the cargo containers into a vivid yet transparent trail, first take a test shot to arrive at a good exposure of the scene, then use the Reciprocity Law (see #050) to estimate an equivalent exposure at 2 to 3 sec to achieve lots of blur. You'll need to add neutral-density filters (here, a stack of five stops' worth was used) to cut the light as it enters the lens (see #137). **TECH TALK: 2.5 SEC AT F/22, ISO 50, 24-105MM F/4 LENS**

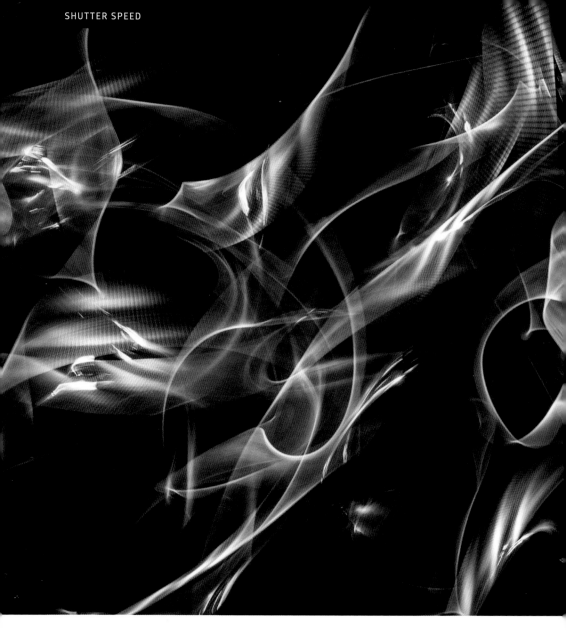

FURTHER PHOTO OPS

The most exciting aspect of lightpainting is the sheer variety of looks you can achieve. Here are some additional ideas for highlighting motion.

MAKE IT A GAME Gather a group of first-time lightpainters and the children's version of the game Pictionary. Drawing the simple prompts (such as grass, fence, and ball) will help you get the hang of making legible shapes with light.

ENHANCE A SCENE Not all lightpainting needs to create wild abstractions or childlike sketches. You can also use the technique to illuminate a subject—say, a beautiful tree in a dark field—by casting a flashlight's beam over its form.

048 PAINT WITH LIGHT

Now that you've learned how to harness long exposures for different artistic effects, why not try your hand at *lightpainting*—a fun, next-level technique for creating vivid patterns of color and light, as in this image by Montreal-based artist Patrick Rochon.

STEP 1 Seek minimal light. Pick a dark spot, indoors or out—maybe with some ambient light to give your composition depth. You'll also need "brushes": light sources with which to paint your abstraction. Here, anything goes—an accessory flash unit, flashlights (perhaps covered with colored gels), sparklers, or glow sticks will all work. You can even play with modifying a light source: Here, Rochon experimented with housing his lights in three-dimensional shapes for more variety.

STEP 2 Frame your scene. With your camera on a tripod (see #116), look through the viewfinder or use live view on the LCD screen to delineate the boundaries of your frame. Note some key landmarks to keep your lightpainting within this perimeter.

STEP 3 Focus the lens manually (see #037). You may need to light up your subject when you do this, or use a stand-in to achieve focus.

STEP 4 Set the exposure. In manual mode, set a low ISO and a midrange aperture (f/8 or f/11). You'll have to experiment with shutter speed, since the timing will depend on how much light you add to the scene. Start with 20 sec and double the time from there—the image you see here is a 23-sec exposure.

STEP 5 You'll need to get out from behind the camera to paint, so use a remote trigger or self-timer (see #118). Wear all black so you don't make a cameo.

STEP 6 Start painting. Keep moving to stay invisible, and experiment with your motions. Here, Rochon introduced an old idea from martial arts: the *kata*, a systematic and repetitive sequence of movements. The result is a scintillating, dynamic design of light. What types of motion could you try for your own effects?

TECH TALK
23 sec at f/18
ISO 100
24–85mm
f/3.5 lens

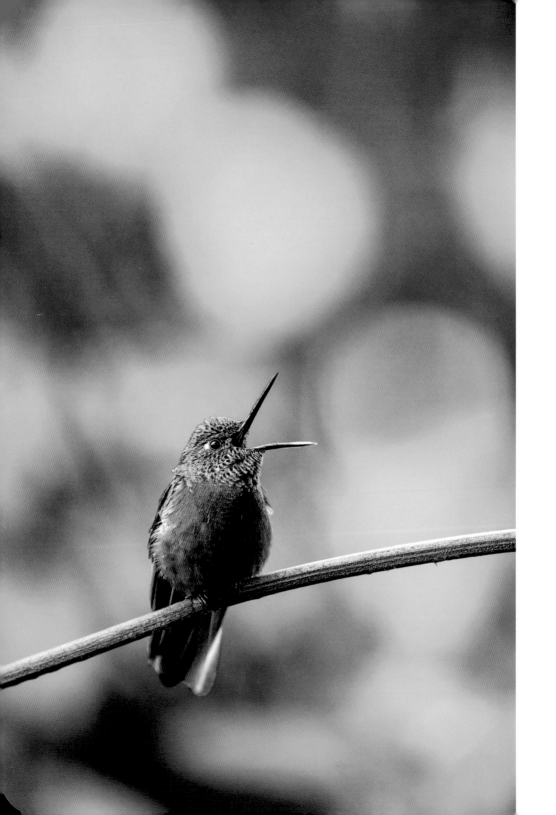

APERTURE

Like shutter speed, aperture—one of our fundamental camera controls—is also remarkably simple. It's a valve (or a faucet, if you will) inside your lens, with a circular, or nearly circular, opening. Open up the aperture wide, and light will come gushing through the lens; close down the faucet to a narrow opening, and light will just trickle through. Beyond rote mechanics, aperture determines how much of the scene will stay in acceptable focus (called *depth of field*). The wider apertures (like f/1.4, f/2, and f/2.8) will keep the foreground object you focused on sharp but will blur out the background—just like our bird image here, taken with a telephoto lens at a wide-open aperture. Meanwhile, small apertures—such as f/16 and f/22—can render the foreground and background and everything in between sharp. So you can think of an aperture setting as a slice of space: Small f-numbers will give you a shallow slice of space; big f-numbers will give you a deep slice of space.

TRY THIS

049 GET A HANDLE ON F-STOPS

Aperture sizes are designated by an odd sequence of numbers called *f-stops*: f/1 (which is rare), f/1.4, f/2, f/2.8, f/4, f/5.6, f/8, f/11, f/16, and sometimes f/22 and f/32. (Like shutter speed, there are intermediate settings between the standard f-stops, too.) The small f-numbers—such as f/1.4 and f/2—stand for big apertures that admit gobs of light and result in a shallow depth of field. The larger f-numbers, like f/5.6 and f/8, admit less light. And the biggest f-numbers of all (such as f/16 and f/22) let in a trickle of light, creating a deep depth of field that's sharp from front to back.

One caveat: An f-stop is not to be confused with a stop, the unit of measure for how much light enters the lens, determined by both the aperture and shutter speed settings (see #050).

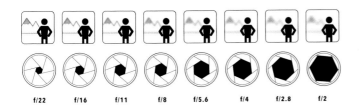

f/22 f/16 f/11 f/8 f/5.6 f/4 f/2.8 f/2

TECH TALK
1/200 sec at f/4
ISO 2000
200–400mm
f/4 lens

CONTROL CORNER
FIND YOUR APERTURE SETTING

Aperture ring on lens
The most traditional placement. Present on older cameras—and new retro-look cameras.

Control panel readout
You turn a command wheel and your setting is seen on a top-deck LCD panel.

LCD monitor readout
You turn a command wheel to a setting shown on the back LCD monitor.

050 EXPLORE THE RECIPROCITY LAW

EQUIVALENT EXPOSURES

Shutter Speed	Aperture
1/2000	f/1.4
1/1000	f/2
1/500	f/2.8
1/250	f/4
1/125	f/5.6
1/60	f/8
1/30	f/11
1/15	f/16

By now you might be getting comfortable with the two fundamental controls of exposure: shutter and aperture. Long exposures and wide-open apertures admit lots of light to the sensor. Short shutter speeds and small apertures admit less light to the sensor. And you can mix up shutter speeds and apertures in various combinations to get good exposures.

Now for a really, really important principle: The amount of light that you gain or lose by going from one standard f-stop to the next (say, from f/2.8 to f/4, or from f/11 to f/8) is exactly equal to the amount of light that you gain or lose by going from one standard shutter speed to the next—from 1/60 sec to 1/125 sec, or from 1/500 sec to 1/250 sec. (These standard chunks of exposure,

via shutter or aperture, are called stops, or EV.) So all settings displayed in the chart at left will actually give you the exact same exposure.

If your head is on fire at this point, splash some cold water on it and relax. The more you shoot, the more this principle (called the Reciprocity Law) will become second nature. While these settings will result in the same exposure—that is, the lightness or darkness of the image—you'll get different effects. To take two extremes: A setting of 1/2000 sec at f/1.4 will freeze pretty much any action short of a speeding bullet, but it will also give you a very shallow depth of field. In the meantime, an equivalent exposure of 1/15 sec at f/16 will blur tree leaves in a breeze but give you a huge depth of field for the forest.

QUICK TIP

051 WORK YOUR APERTURE IN PROGRAM MODE

There's a very simple way to dial in equivalent exposures if you're shooting in program (P) mode. It's called *program shift*, and you do it by dialing a command wheel in one direction or the other. So if you're in a situation where you want to limit depth of field as much as possible, twirl the dial to get the widest available aperture (small f-number). Your camera will then adjust to provide the fastest available shutter speed for your ISO setting. Twirl the dial the other way to get lots of depth of field (large f-number), and the camera will again set the best possible shutter speed. Bear in mind that, with most cameras, the exposure will revert to the standard P mode after one shot. If you like the exposure that resulted from program shift, you can always note the settings, switch to manual (M) mode, and plug them in.

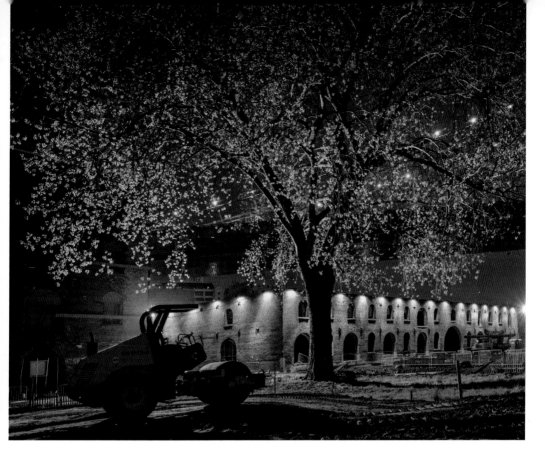

052 GO DEEP—OR SHALLOW

Whether you want a great or shallow depth of field depends on your subject. For portraits, a shallow depth of field (small f-number) works best—it blurs distracting background detail. In landscapes, a deep depth (a big f-number) conveys a sense of dimension, as in this night scene, taken at f/10. But there are nuances galore. A portrait of, say, a mechanic in his garage would be better with enough depth of field to show his environment, while a study of blossoms will benefit from a gauzy out-of-focus background. So use your judgment.

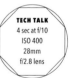

TECH TALK
4 sec at f/10
ISO 400
28mm
f/2.8 lens

053 TRY OUT APERTURE-PRIORITY MODE

You can command your camera to use a specific aperture with *aperture-priority mode*, often indicated by "A" or "Av" and found near the program (P) and shutter (S or Tv) modes. In this mode, the camera automatically varies the shutter speed to create a correct exposure while maintaining the aperture of your choice. You can, however, run into trouble: If you set a small aperture in dim light, the shutter will stay open a long time—and possibly cause blur due to hand shake or subject motion. You can get a faster shutter speed by upping the ISO.

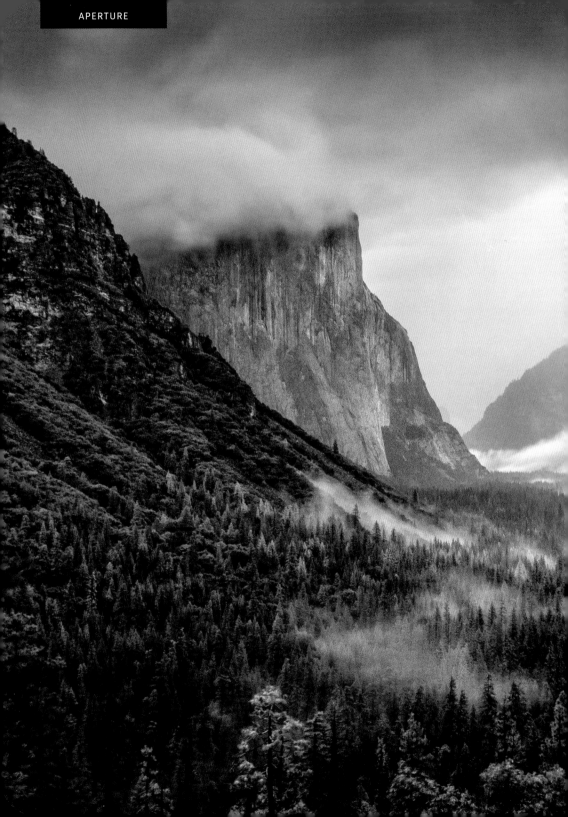

TECH TALK
10 sec at f/22
ISO 100
16–35mm
f/2.8 lens

054 GO THE DISTANCE

The only way to do a sweeping vista justice is to ensure it's crisp from front to back. In these cases, go with a small aperture like f/22, which helped Susan Taylor see deep into this classic Yosemite landscape. You can set the maximum depth of field by focusing your lens to its *hyperfocal distance*: the closest point you can focus on to keep everything behind that point within your chosen depth of field. First, put your camera on a tripod. Set a small aperture, then use live view on the LCD to compose your shot. Working in manual focus (see #037), press the *depth-of-field* (DOF) *switch* (which stops down your lens to your selected aperture), and focus on the farthest point you want within the depth of field. Then focus the lens progressively closer until that far object gets a little soft, then back up the focus until it's just sharp again. Check the sharpness of both the farthest and closest points and if they're good, shoot away.

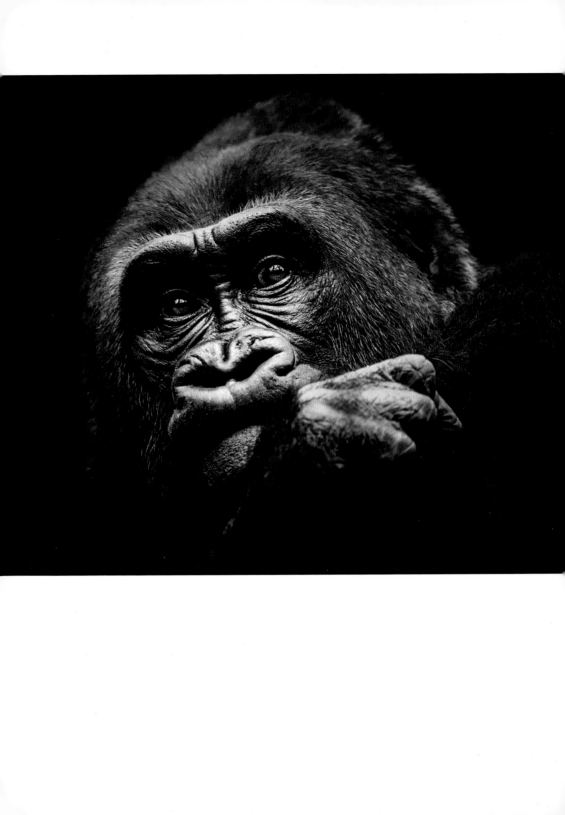

ISO

Sooner or later, you're going to run low on light. Whether you're shooting beach volleyball at sunset or late-night candids in a bar, low light causes the same problem: Despite a wide-open aperture, you can't boost shutter speed enough to prevent blur. Even if your subject is fairly still (like this gorilla), it may be tricky to capture his features in such a dark scene. You can't increase light in these situations, but you can turn up your camera sensor's sensitivity to it with the control called ISO. ISO numbers run in the sequence 100, 200, 400, 800, 1600, 3200, 6400, and often higher. Every time you double the ISO—say, from 200 to 400—you gain enough sensitivity to go a full shutter speed faster, or to close down the aperture by a full stop. Helpful, yes, but not without its bugaboos, as we'll soon see.

055 MINIMIZE NOISE AT HIGH ISOS

If higher ISOs solve so many problems, why not crank it up all the time? There's no free lunch here: At high ISOs, image quality deteriorates, creating *noise*: ugly grain and mottling. Turning up the ISO amplifies rogue electrons in the camera's circuitry. It's a lot like jacking up the volume on a weak radio station—you get more sound, yes, but also more static.

Enter *noise reduction* (NR), a process by which the camera

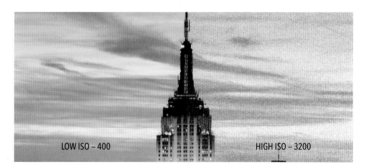

LOW ISO – 400 HIGH ISO – 3200

applies a "smoothing" filter to mask noise, but at a cost: Images will be less sharp. At very high ISOs, the drop in resolution can be quite steep, and the images will still be pretty noisy.

All cameras are set to a default NR, which can be turned up or down via your camera's setup menu. In practical terms, most recent DSLRs and ILCs can produce sharp images with low noise up to ISO 800 to 1600. By ISO 3200, however, things get dicey on some cameras, and by ISO 6400, almost all cameras produce images with noticeable noise and/or loss of sharpness.

TECH TALK
1/250 sec at f/5.6
ISO 3200
80-400mm
f/4.5 lens

CONTROL CORNER
FIND YOUR
ISO SETTING

Dedicated button
A press brings up ISO numbers on a control panel or the LCD monitor.

Quick-control panel
Bring up the panel with a button, then access ISO via a four-way controller or command wheel.

Touchscreen Scroll to the ISO tab, then navigate to and touch the desired setting.

056 GO LOW (AND SLOW) WITH ISO

What advantage do you get with low ISO settings? First of all, quality, quality, quality.

Pictures taken at low ISOs are sharp, with fine grain and clear rich colors. It's no wonder that landscape enthusiasts will keep ISOs as low as possible, and if they have to lug around a tripod to maintain a low ISO but prevent shake, so be it. And it's why portraitists would rather pour on more artificial light than up their ISO settings.

Keeping ISO low lets you shoot with wide-open apertures to isolate single elements in the frame, as in the photo at right. And there are times when you really need low ISO settings—when it simply will not be negotiable. For instance, if you want to use a slow shutter speed in a panning action shot (see #044), high ISOs will be only be an impediment, particularly in bright daylight. In a situation like this, even with a very small aperture, you may end up with a shutter speed so fast that an image of a bicycle racer will have little or no streakiness in the background. And if you want to blur moving water and transform it into in a silky, ethereal flow—and not

just a slight blur—low ISOs are a must. You'll also need ISOs as low as they can go (and maybe filters) to experiment with the depopulation effect (see #138). And some landscape shooters deliberately go for a lot of blur in order to, say, transform a field of wildflowers into an impressionistic field of color. Similarly, if you're doing outdoor portraits, and want to blur out the background with a very wide aperture (like f/1.4 or f/2), a low ISO is the only way to go.

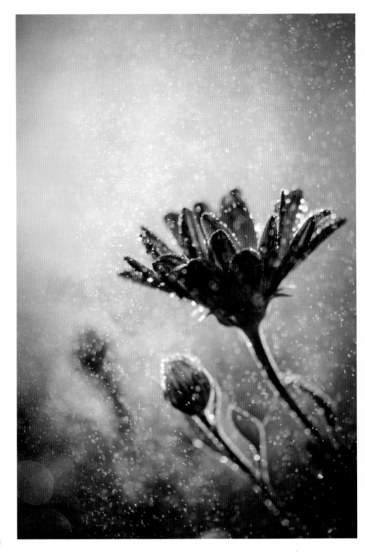

TECH TALK
1/800 sec at f/2.8
ISO 200
60mm
f/2.8 lens

057 PINCH-HIT YOUR ISO SETTING

Many serious photographers use a precise method to optimize their ISO settings, whether they're shooting landscapes, portraits, still lifes, or other genres. This is a technique best used with manual exposure (see #066–070). First, determine and make the exposure settings that you need: a certain shutter speed to prevent subject blur, for example, and a certain aperture to get the necessary depth of field to achieve the aesthetic that you're after. Then adjust the ISO so it is just high enough to result in those settings—that way, you keep noise to a minimum.

058
MASK NOISE WITH B&W

If you absolutely have to use very high ISOs to get a shot, consider converting the image to black and white. It can give you the old-timey effect of gritty, grainy high-speed B&W film, which may make the noise less obtrusive.

TECH TALK
1/200 sec at f/8
ISO 100
105mm
f/2.8 lens

059
TURN ON THE DARK

Photographers often fear darkness. For many of us, it's associated with obscured subjects, blur from movement and bad focus, and the inability to see while shooting. But darkness can actually be a blessing in your images—if, of course, you know how to wield it. Just think of it this way: If photography is writing with light, darkness is the punctuation. Darkness defines shapes, makes two dimensions look like three, and heightens drama. It can even be a subject in itself. Here are a few ways you can achieve dark victory.

FRAME WITH DARKNESS Use a tunnel, a dark interior window, or a backlit landform in the foreground as a natural framing device. Be sure to expose for the scene that's inside the frame, not for the frame itself. **TECH TALK: 1/100 SEC AT F/13, ISO 200, 24-70MM F/2.8 LENS**

SNAG A SILHOUETTE Try defining forms by reducing them to dead black, called a *silhouette*. For a perfect silo, meter off the bright background and allow the edges of your subject to be rim-lit by the light source behind it. **TECH TALK: 1/2000 SEC AT F/5.6, ISO 200, 600MM F/4 LENS**

DELIBERATE UNDEREXPOSURE

For a dramatic portrait in a dark outdoor scene toward the end of the golden hour, allow just enough exposure to define the subject's face, and let the background go underexposed. It also pays to use a large enough aperture (see #049) to blur out the background. **TECH TALK: 1/1000 SEC AT F/4.8, ISO 800, 18-55MM F/3.5 LENS**

DIY CHIAROSCURO

To truly embrace the dark side, try *negative reflectors*—black cards also known as *flags*—to tone down bright areas, prevent light spillover, and define shapes. You can achieve similar shadows by adjusting the angle of an open door to focus light on your subject. **TECH TALK: 1/1250 SEC AT F/4.5, ISO 800, 18-300MM F/3.5 LENS**

WHITE BALANCE

All light has color, even light that appears "white." Our eye-brain computers adjust automatically to see many colorcasts as neutral or near-neutral tones. But in reality, bright daylight is quite blue, dark overcast bluer still, and tungsten illumination (from household bulbs) is yellow-amber. And your camera's digital sensor will record these colorcasts, unless otherwise instructed by a camera setting called *white balance* (WB), an electronic color filter that compensates for the colorcast of the scene. WB doesn't get any easier than *automatic white balance* (AWB), which is the default setting of most cameras. AWB performs great in many situations, particularly in rapidly changing light and when you happen to go from sunlight to shadow or outdoors to indoors. It also knows when you're using flash. But there are times when AWB just can't render a scene to your liking—if, say, you've got a bright splotch of red in an otherwise neutral scene, as at left, it may throw off AWB. Or if you're shooting in nasty artificial light, colorcasts can turn out stranger than fiction. So in this section, I've gathered tactics for tricking your camera into capturing true color—regardless of what it thinks it sees.

CONTROL CORNER
FIND YOUR WHITE BALANCE SETTING

Dedicated button Takes you right to the menu for WB selection.

Quick menu Opens up a menu screen where you select WB, then choose from a submenu.

Touchscreen Leads to a menu screen where you select WB, then touch your selection.

TECH TALK
1/320 sec at f/5.6
ISO 100
17–35mm
f/2.8 lens

060 SET A CUSTOM WHITE BALANCE

Believe it or not, a simple piece of gray cardboard is your US$3 ticket to neutral color and dead-on exposure—carry one with you to set your camera right before you shoot to avoid messing with WB issues later. This trick is great when you're shooting in mixed light or (heaven forbid) under fluorescent lights.

STEP 1 Hold (or ask your subject to hold) a photo gray card so it appears in the light you'll use for your final shot.

STEP 2 Stand back a few steps, and compose so the gray card fills your frame. Set your exposure accordingly and take a photo.

STEP 3 Navigate your camera's menu options to locate its list of white balance settings. (This procedure differs among various camera makes and models, so check your manual.) Select the custom white balance option and then choose the test photo you took with the gray card as the reference image.

STEP 4 Remove the gray card and start shooting for real. If the light changes, take another shot with the card and use it to set a new custom white balance.

061 CONTROL COLOR MORE WITH PRESETS

Automatic white balance is very smart, but it's not foolproof. Large areas of predominating color in a scene, or a brightly lit object in a darker surround, can throw off AWB. A classic example: sunsets. Our eye-brain computers see the brilliant golds and reds, but with AWB, they can turn out . . . blah.

This is the right time to opt for a *WB preset*, a setting that locks in a specific color balance for you. You access presets via a menu; on some cameras, an external button will allow a quick jump to the settings. Presets are denoted by standardized icons, as described at right. In the case of that gorgeous sunset, use a daylight preset and the colors will come through—the camera won't compensate for them. To use a preset, choose one that most closely matches your lighting situation. One pitfall: If you forget about the setting and the light changes, your pictures will show an offcast.

On many cameras, individual WB presets also let you push the balance warmer or cooler via menu adjustments. (These may also allow you to nudge the hue along the magenta-green axis to counteract any green casts caused by fluorescent lighting.) Another fine-tuner found on some cameras lets you move the WB point around on a graph.

Icon	Lighting
☀	Sunny, blue skies with or without clouds; hazy bright
🏠	Open shade on sunny days
☁	Overall cloudy; mists and fog
💡	Tungsten lighting
(fluorescent)	Fluorescent lighting
(fluorescent 2)	Warm-white fluorescent (not on all cameras)
(fluorescent 3)	Cool-white fluorescent (not on all cameras)

062 COOK WITH KELVIN TEMPERATURE

An image's white balance is traditionally measured in Kelvin. At first, this system may seem counterintuitive: Low Kelvin temps (around 2500 degrees) are very warm, while high Kelvin temps (8000 degrees) are very cool. (Think of the warm amber of dying embers, or the cold blue hue of a welding torch flame.)

To adjust WB in Kelvin, go into the WB menu and nudge it a little warmer or a little cooler.

Note that the Kelvin settings are filters that compensate for the scene's color tone. For example, a Kelvin setting of 2500 is a blue filter that compensates for the warm amber light of household bulbs, while a Kelvin setting of 8000 is an amber filter that compensates for the cold blue of shade on a sunny day. Here are Kelvin temperatures of common light sources.

Light Source	Kelvin Temperature
TUNGSTEN LIGHTBULB	2500K
EARLY MORNING/LATE AFTERNOON	3500–4000K
DIRECT SUNLIGHT OR ELECTRONIC FLASH	5500–5800K
OVERCAST	6000K
OPEN SHADE ON A BLUE-SKY DAY	8000–10,000K

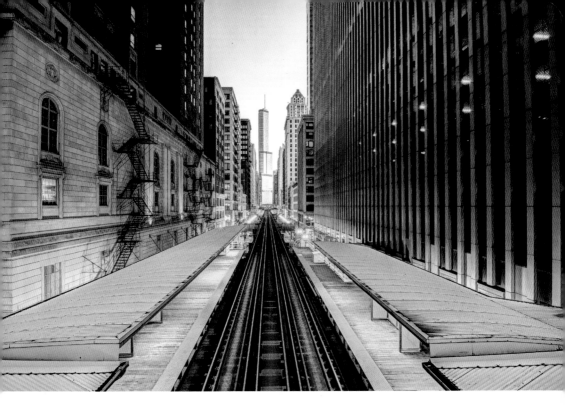

063 COPE WITH MIXED LIGHTING

TECH TALK
4 sec at f/16
ISO 200
10–24mm
f/3.5 lens

When it comes to white balance, mixed light sure is a mixed bag. Here's how to deal when your scene is lit by multiple light sources with varying color temperatures, as in this tungsten-lit street scene at blue hour.

GO AUTO One way of keeping color correct in mixed light is to use automatic white balance, which will give you an average reading weighted toward the predominant tone. The problem here is that it can give you a mishmash setting in which nothing is really in the correct white balance.

PICK A COLOR TEMP A better approach when working in mixed light may be to set WB specifically for the most important area in the frame and let others fall where they may. For example, let's say you're shooting in a room lit by overhead tungsten lamp bulbs, with daylight coming through windows in the background. Set WB for tungsten to keep the interior fairly neutral, and let the outside light go very blue.

QUICK TIP

064 SPOT-CHECK WHITE BALANCE IN LIVE VIEW

For a real-time check of the effect of your white balance setting, go into your camera's live view. It shows you the color balance that the sensor sees.

ONE SCENE, FOUR WAYS

065
EXPERIMENT WITH WHITE BALANCE

When you're working with white balance, neutral is often king: You want to replicate the scene's color as it appeared before your eyes, and you use your camera's white balance tool to correct "misreadings."

But sometimes it's more of a matter of taste or creative impulse. Take this foggy mountain view, adjusted a few different ways so you can witness white balance at work. This photo is a good choice for playing with white balance because of its gray tones—the WB could go in almost any direction without looking unrealistic. You can try your own white balance experiment; just remember that the white balance setting compensates for the scene's light, so a Kelvin setting in the low end (2500–4000) is a blue filter, and one at the high end (5000 and above) is an amber filter.

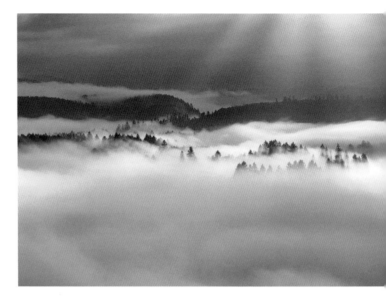

COOL IT DOWN Set just to the left of neutral at 3700 Kelvin, this cold touch results in an evocative, moody image with bluer tones. Note that this Kelvin setting is a blue filter that compensates for the amber light of, say, light bulbs–hence, the image appears blue.

KEEP IT NEUTRAL Processed at 4400 Kelvin, this version of the image is closest to "real." There's a nice range of tones, with warm sun, cool mountains, and silver fog. Some viewers might be drawn to its faithfulness to the original scene; others might be bored.

WARM IT UP At 5500 Kelvin, you can imagine you're seeing the warm rays of early morning spreading through the fog bank. It's a viable picture but not the only interpretation. Here, note that the Kelvin setting is an amber filter that compensates for the blue color of bright daylight.

WARM IT WAY UP Here is warmth in the extreme at 6500 Kelvin, without almost any trace of the natural blue. Many would say this is fun with white balance gone too far—overcooked, in fact—but it depends on what you're after.

MANUAL EXPOSURE

Long before autoexposure, photographers set shutter speed and aperture themselves, either in consultation with a light meter or an exposure calculator. Accomplished photographers today still use *manual exposure* in situations in which maintaining precise exposure settings is paramount.

The key to manual mode is that once you set an exposure, it stays there until you intervene again. There's no interference from an automatic mode—if you move a dish in your still life or have your model change into an outfit of another color, the in-camera meter won't boss you into a different exposure setting. But, of course, this means you're on the hook for making sure your exposure works if you, say, wander into a patch of different light. And, while it may seem counterintuitive, manual exposure is often a better choice for fast-moving subjects—it will hold on to your set exposure for the subject and not be thrown off by any sudden change in background.

066 PICK THE RIGHT TIME FOR MANUAL

Here are typical situations for use of manual exposure.

STATIC SETUPS Manual is excellent for carefully set-up, unchanging scenarios, such as still lifes, product shots, artworks, and so on.

STUDIO PORTRAITS Opt for manual when the exposure for one particular area is all-important. For instance, in the model shot at left, you want to make an exposure for the model's face and hair, and keep it constant regardless of the lightness or darkness of the outfit.

MIXED LIGHTING For setups combining flash and ambient lighting, you may want to set the exposure for the background manually and then leave it there for all subsequent flash adjustments, even when using TTL autoflash (see #148).

QUICK SUBJECTS Paradoxically, manual exposure works better for some stadium sports. Consider a football running back: During a long run, he may pass in front of a bench full of light-colored uniforms, then be surrounded by defenders in dark uniforms—but the light on the runner is the same in both instances. Autoexposures will land all over the place, whereas a manual exposure specifically for the running back will keep the exposure setting constant.

TECH TALK
1/80 sec at f/8
ISO 800
85mm
f/1.8 lens

CONTROL CORNER
FIND YOUR MANUAL SETTING

Traditional dial
Just twirl it to M, and you're set.

Command wheel
Hit the mode button, then twirl a command wheel to M on an LCD control panel.

Touchscreen Access an on-screen menu by button or other control, then select M.

067 SET MANUAL EXPOSURE

Universally, the manual-metering indicator is a graduated scale in the viewfinder or on the LCD screen, either horizontal at the bottom or vertical at the side. It looks like a ruler: The central zero point is what the camera's meter deems correct exposure. The minus (–) end of the scale indicates underexposure; the plus (+) end of the scale indicates overexposure. The scale is usually gradated two or more stops on either side of the center zero point, in one-third stop increments. You can adjust either shutter speed or aperture to move an arrow along the scale to the desired exposure. If your settings are so over or under as to be beyond the scale markings, you'll get a warning blinky in the viewfinder and the LCD monitor.

STEP 1 Pick a light-metering mode: evaluative, center-weighted, or spot (see #017).

STEP 2 For a quick starting point for an exposure setting, set the exposure-mode dial to P (program).

STEP 3 Compose your image or aim the spotmeter at a desired tone, then half-press the shutter button to get a suggested meter reading—it will display on the viewfinder and the LCD screen. Make a note of that reading.

STEP 4 Set the exposure mode dial to M (manual) and transfer the meter reading to the camera.

STEP 5 Evaluate the exposure, and adjust if needed. If you're photographing a landscape with the camera on a tripod,

for example, a small aperture (such as f/11 or f/16) may be a priority. Once you've set that, you may have to readjust the shutter speed to recenter the arrow on the exposure scale. If you're photographing a portrait subject, a reasonably fast shutter (1/250 sec) may be essential. And similarly, you may have to fiddle with the aperture setting to get back to a centered exposure.

STEP 6 Can't nail your desired exposure? Raise or lower the ISO to get more or less sensitivity. (Go with higher ISOs for a faster shutter and/or smaller apertures; lower ISOs for a slower shutter and/or wider apertures.)

STEP 7 Shoot away, adjusting the exposure above or below the center point if you see fit.

RULE OF THUMB

068 CUT CORNERS WITH SAVED SETTINGS

Manual exposure is great for regularly repeated tasks. Say you have a tabletop setup for photographing items to sell online. With manual, once you set exposure, you can leave it there for the whole shoot. But if you use the same camera for other shots, it's a hassle to continually reset exposure for your tabletop work—so stop! Cameras today have a mode that lets you save every shooting parameter in a memory location, which you can call up with a single turn of a dial or touch of the menu item.

QUICK TIP

069 COUNT THE CLICKS

You've likely noticed weird intermediate numbers for aperture (such as f/3.2 and f/3.5) and shutter speed (1/40 and 1/50 sec). Each represents exactly 1/3 stop, or 0.3 EV. If you go three clicks, it's exactly a stop, and if you go three clicks with one control, you can shift the other control three clicks to get an equivalent exposure.

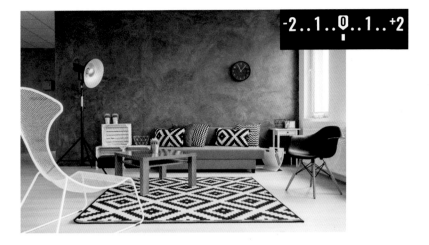

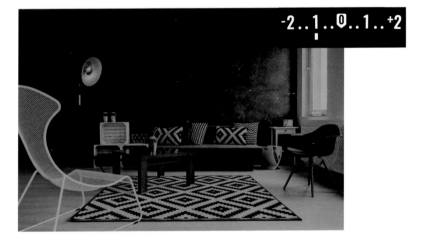

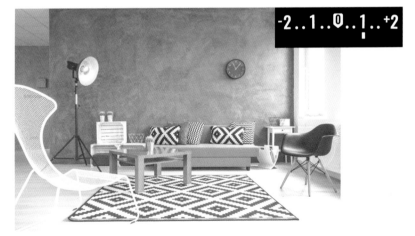

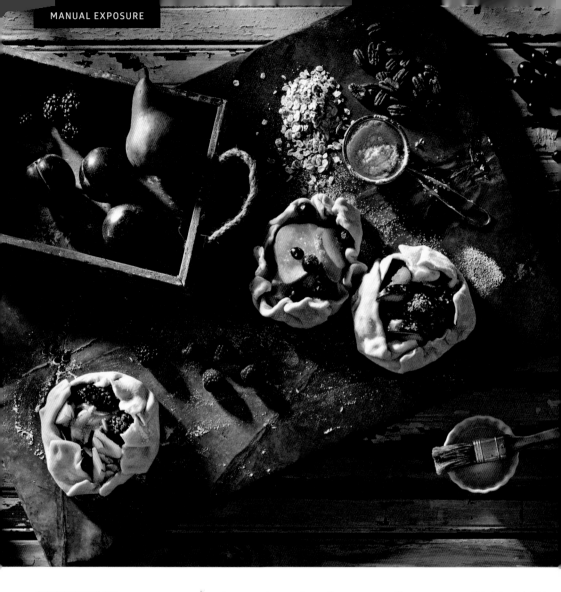

FURTHER PHOTO OPS

Let's say you want to experiment in manual mode, but you're not into that whole seventeenth-century Dutch Masters look. Here are some other manual-friendly setups to explore.

CAPTURE THE GREAT OUTDOORS When you're shooting a landscape with a strong anchor element–say, a bridge, farmhouse, or magnificent old tree–take your time to set up a manual exposure. None of your subjects are going anywhere, so it's a perfect opportunity to experiment with aperture and shutter without the pressure of a rapidly changing scene.

CAPTURE THE SMALL OUTDOORS Have a flower bed coming into bloom in your yard? With even, nondirect daylight or bright overcast, this is an ideal opportunity to set up on the tripod to get the perfect exposure of that perfect blossom. Start with aperture first–you want the background out of focus–then experiment with shutter speed, taking test exposures until it looks just right. With direct sunlight early or late in the day, you may have to work faster, but practice will get you there.

WEDDINGS, PARTIES, MEETINGS BY FLASH At times like these, when you're serving as the record keeper, you're looking for repeatability, not art. So set a ghost-proof shutter speed of, say, 1/200 sec, and a medium aperture like f/8, with manual exposure. Then let your TTL flash on auto do all the exposure work (see #143).

070 CRAFT A MOODY STILL LIFE IN MANUAL MODE

Photographers who swear by manual mode love its "set it and forget it" aspect: Once you dial in your ideal exposure, the shutter speed and aperture won't change until you tell them to. This is great for still lifes, when the image making is all about subtle moves in props and lighting.

STEP 1 Gather your subjects. Here, Nashville food specialist Kyle Dreier brought together a quartet of rustic tarts and their ingredients, plus a few surfaces for variety.

STEP 2 If you're after dramatic illumination, aim to shoot in the late afternoon when the sun is low, which will send light strafing over your subjects and create long shadows. (Full disclosure: This image was created with a light covered in orange acetate to mimic a low sun's effect.) If there's too much darkness, open up the shadows with a reflector (see #152).

STEP 3 Lock your camera on a tripod and tilt the head so it faces down (see #120), then select a metering mode. If your scene has a nice overall tone, opt for evaluative metering; if there are areas of high contrast, go with spotmetering. Use a gray card (see #016) for a dead-on midtone.

STEP 4 Set your camera to M for manual mode. Half-press the shutter to meter your scene, and look through your viewfinder to see if the indicator arrow is to the right or left of center. For still lifes, a small aperture is crucial, as it will allow you to keep the entire scene crisp. So once aperture is set, adjust shutter speed to land the indicator dead center.

STEP 5 Take a test shot and check your histogram (see #014). Adjust your shutter speed to account for any problem areas, going over or under the meter's center as needed. If your speeds get really slow—longer than 1 sec—you may want to up ISO to allow use of faster speeds and prevent blur.

STEP 6 Now that you have an exposure setting you like for your scene, forget about it and go about composing your shot—scooting tarts, berries, and sifters until you achieve the composition you're after.

TECH TALK
1/125 sec at f/11
ISO 200
120mm
f/5.6 lens

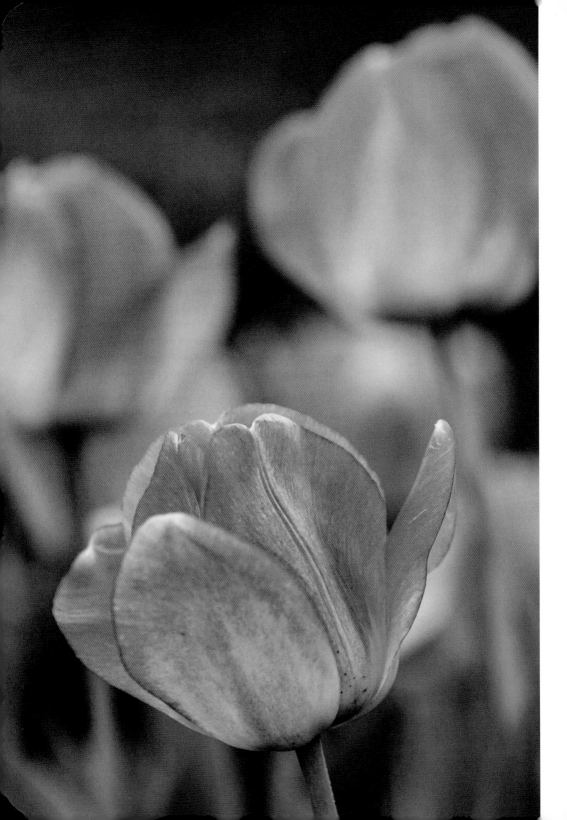

BUILT-IN FLASH

A built-in flash, found on consumer-level DSLRs and ILCs, doesn't get a lot of respect from some photo enthusiasts who disdain it as an amateur feature. "Too weak!" "Can't get it off the camera!" "Too automatic!" We beg to disagree. Yes, it has its limitations, but it is bottled light always at the ready, and it is often just the ticket for quick and easy snapshots—especially when working in low-light situations, when your subject is backlit, or when bright sun overhead casts inky shadows that you'd like to open back up. If you're shooting outdoors, popping your flash in broad daylight can also help you achieve richer colors and a certain "pop," as it did for these lovely spring tulips. But the real advantage of *speedlight*, as it is often called, is that its burst is extremely short in duration—anywhere from 1/1000 sec to 1/20,000 sec. This instantaneous flare enables you to freeze action in low light. It may even help you achieve some surprisingly creative effects along the way.

CONTROL CORNER
FIND YOUR FLASH

Pop-up flash Found on DSLRs, this flash deploys at the press of a nearby button, or just raise it by hand.

Button-deployed flash Common on ILCs with off-center flashes, the unit is engaged via a nearby button.

Flash-mode menu Once the built-in flash is deployed, an array of modes (see right) is available by menu, quick-control panel, or touchscreen.

TECH TALK
1/250 sec at f/4
ISO 100
70-200mm
f/2.8 lens

071 CHOOSE YOUR LEVEL OF FLASH CONTROL

Built-in flashes have three levels of automation, which are represented by icons and accessed via a menu or by a dedicated control.

AUTOFLASH The camera decides to fire the flash or not, depending on your scene's light level. Autoflash is what you get, without option, in all-auto or scene-exposure modes (see #003). But in P, S (Tv), A (Av), or M modes, you get to choose whether you want autoflash or another flash mode. Autoflash limits how low your shutter speed can go, so in low light you may get a dark background.

FLASH ON Here, you're telling the flash to fire every time. Also called *fill* or *forced flash*, this tactic helps in bright to medium light when you want to soften harsh shadows in portraits or to pop colors in subjects like flowers. It also limits the shutter speed, so dark backgrounds can happen in dim light.

SLOW SYNC This mode will fire the flash every time, but it won't limit the shutter speed, so you can balance the flash exposure with dim lighting indoors or darkening skies outdoors.

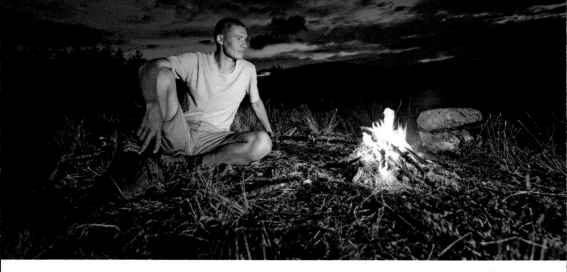

072 BALANCE FLASH AND AMBIENT LIGHT WITH SLOW SYNC

While your built-in flash may be no hero in terms of illuminating a full scene, it can give the ambient light a boost when paired up with slow sync—to fascinating effect. It's perfect for shots on the wedding reception dance floor, portraits in front of a setting sun (or around a campfire, as in the shot above), and other low-light situations where a bit of creative lighting goes a long way.

STEP 1 Set the camera to P (program) mode and evaluative metering.

STEP 2 For a moderately well-lit room, start with ISO 400. For darker rooms, or for dim conditions late in the day, go with ISO 800 or 1600 to avoid background blur.

STEP 3 Turn on image stabilization, if your camera has it, or put the camera on a steady support.

STEP 4 Turn on the flash, and in the flash menu, set it to slow sync.

STEP 5 Focus on your subject, and take the shot.

STEP 6 Experiment! Try the background exposure lighter or darker with exposure compensation, and the flash exposure lighter or darker with flash compensation.

TECH TALK
1/4 sec at f/2.8
ISO 800
14mm
f/2.8 lens

073 WORK FLASH-EXPOSURE COMPENSATION

The control called *flash-exposure compensation* works like regular exposure compensation (see #020), except it's applied solely to the flash output, independent of the ambient exposure. Usually summoned up by a menu, you adjust it the same way you do EC: on a graduated linear scale marked in 1/3 EV (exposure value, or stop) increments.

PORTRAIT FILL IN DAYLIGHT Set your flash exposure compensation at –1.0 EV

or a little lower to soften harsh facial shadows or for a boost in backlit portraits.

WALKING-AROUND SHOOTING As a matter of course, set flash EC at –1.0 EV to provide a quick fill for flowers, found objects, tiny critters, or friendly people you meet.

CATCHLIGHTS In a softly lit portrait, your subject may lack catchlights—those important bright little dots that make eyes come alive. Try setting around

–2.0 EV flash to bring them back and make subjects look lively.

THE PAPARAZZI LOOK Cast subtlety to the winds, set flash EC to +0.7 EV or even higher, and underexpose the ambient exposure to make your subjects pop garishly against a dark background.

FURRY FRIENDS You can enhance the sheen and texture of a dog or cat's coat with a pop of about –2.0 to –1.0 EV— especially helpful for dark pets!

074 COPE WITH THE FLAWS OF BUILT-IN FLASH

I regret to inform you, reader, that once again there is no free lunch. Of the drawbacks to built-in flash, here are the major ones.

LOW POWER A typical DSLR pop-up flash is limited to about 11 feet (3.4 m) with an f/3.5 lens at ISO 100; an ILC flash may have no more range than 5 feet (1.5 m) at the same parameters. Boost the ISO for more flash range: At ISO 400, you can get 22 feet (6.7 m) and 10 feet (3 m), respectively.

LENS SHADOW When shooting very close, or with a big lens hood, or a physically large lens mounted

on the camera, you may get the actual shadow of the lens in the picture. To nix this shadow, move back from the scene, remove the lens hood, or mount a smaller lens.

THAT FLASH LOOK Direct flash in low light is harsh, makes distinct shadows behind subjects who are standing close to walls, and can cause the dreaded red-eye. To fix, try to move your subjects into brighter light, shift them farther away from walls, and use the anti-red-eye setting of the flash (annoying!) or fix it later in software (better).

SOFTWARE SAVE

075 GET THE RED OUT

Yes, you can get red-eye when using built-in flash, even if you've triggered that annoying preflash or bright-beam red-eye prevention. Red-eye is easy enough to remove after the fact; most image-

editing programs have a red-eye removal tool, and they are pretty much automated. Open the photo in the editor, draw a box or circle around the affected eyes, and select the remove-red-eye command from a drop-down menu. Some cameras have a red-eye-removal tool built right into the camera.

See Through the Lens

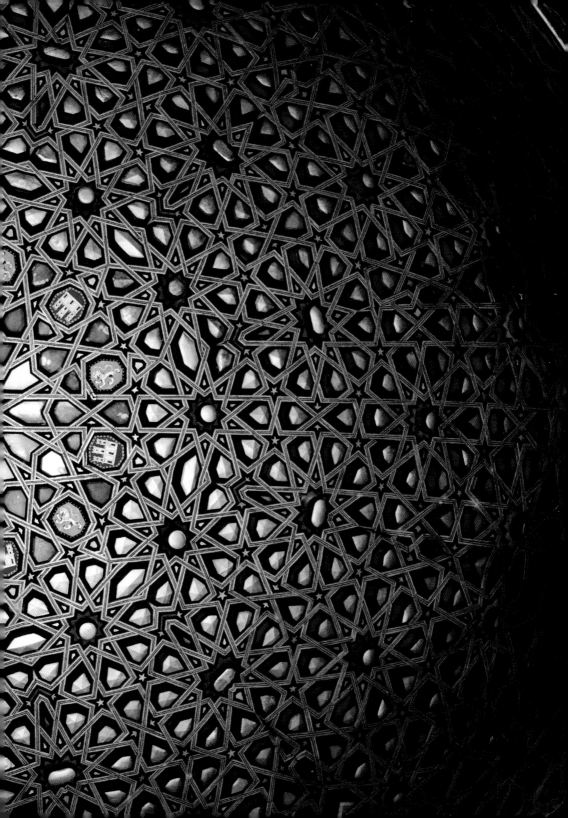

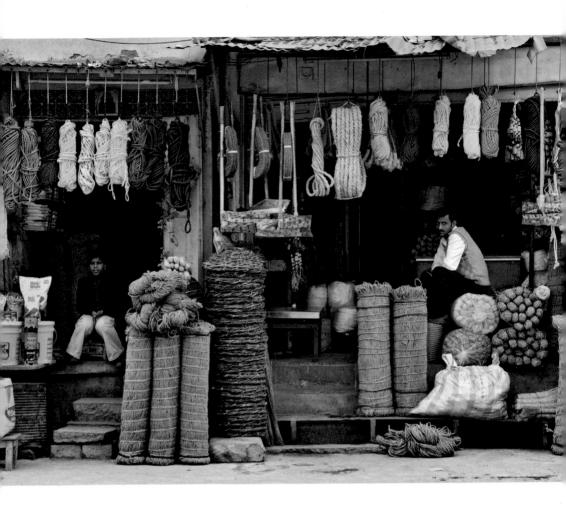

FOCAL LENGTH

Focal length is a key issue in photography—it will surely impact the look of every picture you ever take. It has a scientific definition, but we're not going there. Instead, here's what focal length does: It determines how much, or how little, of a scene you can fit into the frame. Put another way, different focal lengths allow you to take in a wide expanse of the world in front of you, give you a view much like your normal vision (like the street scene at left), or make distant scenes seem closer. These classes of focal lengths are termed, in order, wide-angle, normal, and telephoto (or simply long).

Chances are you have a DSLR or ILC camera that came bundled with a *zoom lens*—an optic that lets you vary the focal length with the turn of a ring or press of a lever, which is very convenient and adaptable to many shooting situations. But we're going to start by talking about various focal lengths individually so you can experience firsthand how they can expand your view on the world.

076 SEE HOW FOCAL LENGTH MEASURES UP ON DIFFERENT SENSORS

FULL FRAME
APS-C
MICRO FOUR THIRDS

Focal length is universally measured in millimeters (with 50 millimeters being equal to just about 2 inches). What does this number mean? The shorter (smaller) the focal length, the wider the lens's field of view. The longer (greater) the focal length, the more the lens magnifies distant objects.

Sounds pretty straightforward, but of course there is no free lunch: How much of a scene a lens can capture depends on the camera's *format*, which is determined by the size of its digital sensor. Commonly used interchangeable-lens

TECH TALK
1/80 sec at f/6.3
ISO 200
24-70mm
f/2.8 lens

digital cameras fall into one of three formats: *full frame*, which is the size of the 35mm film frame (24-by-36mm); *APS-C* (often called crop sensor), which measures a little less than half the area of a full frame; and *Micro Four Thirds* (MFT), coming in at about one-quarter the area of full frame.

The smaller the sensor, the smaller the view that the lens sees. So, that 50mm lens (when mounted on a full-frame camera, which tends to be the most upscale) will give you a true normal field of view. Attach it to an APS-C camera, and you'll see a tighter view—about that of a 75mm on a full frame. Mounted on a Micro Four Thirds camera, you'll see a still-closer slice of the scene: about the angle of a 100mm on a full frame. Confusing? Learn your camera's sensor size, and look at the equivalent listings given for each format as we discuss different focal lengths.

077
TAKE CARE OF YOUR LENSES

It's like medical practice. First, do no harm. Then proceed with great care.

PUT IT AWAY PROPERLY Don't leave lenses loose to tumble around in a bag; use lens cases or padded compartments.

CAP IT ALL Dust is the enemy of digital sensors. Never leave a detached lens without a rear cap, nor a lensless camera body without a body cap.

KEEP 'EM TIDY To clean a lens, start with a no-touch method and use a bulb blower to remove dust. If dust persists, use a soft brush designed for camera lenses.

BREAK OUT THE BOOZE For greasy spots, wet a cleaning cloth with a drop of lens-cleaning fluid (or vodka), then rub the lens down. Never apply fluid directly to the lens.

FIGHT MOISTURE Store lenses and cameras with chemical dry packs, especially if you live in a damp environment.

FEND OFF WEATHER Protect your lens from rain with a rain sleeve. If a lens does get wet, wipe it off immediately with a microfiber cloth and let it dry at room temperature.

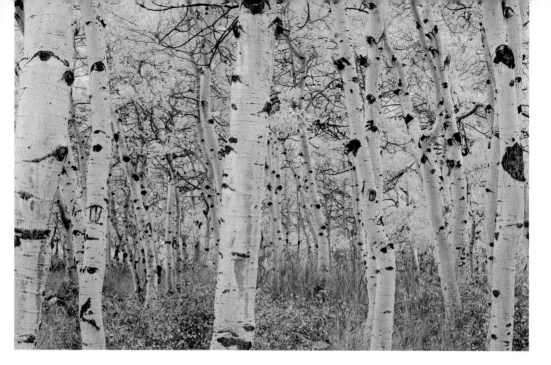

078 LEARN WHAT MAKES NORMAL "NORMAL"

Our stereoscopic vision take in a remarkably wide field of view (and even one eye takes in quite a wide area). But our greatest visual acuity is concentrated in the center of that field. So-called *normal focal lengths* provide a similar view through the lens. Much like a plain window with a frame around that field, the image looks neither magnified nor reduced. In the lingo, normal.

Normal focal lengths are defined as the measure of the diagonal of the sensor. It's 43mm for full-frame, although, in practice,

normals are usually a bit longer (50 or 55mm for a full-frame format). A normal focal length is neither too long nor too short; it trains a photographer's eye to see rather than just aim.

The normal view is great for all kinds of pictures: half-height and head-and-shoulders portraits, small group portraits, candids in almost any indoor or outdoor situation, and classic scenic shots like the autumnal trees above. What makes this view natural isn't just its moderate field of view. It's also the relation of the sizes of objects within the frame. At

typical distances, like 5 to 30 feet (1.5–9 m), objects behind your subject will appear to have the same size relationship as they do in your own vision. This conveys a strong sense of being right in the scene.

Here's a good exercise: If your lens is a zoom, set the zoom ring to the normal focal length. Now tape the zoom ring there with gaffer or masking tape. Then spend a day (or a week, or more) shooting at just that focal length.

Camera Format	Normal Focal Lengths
FULL FRAME	45–60mm
APS-C	30–40mm
MICRO FOUR THIRDS	22.5–30mm

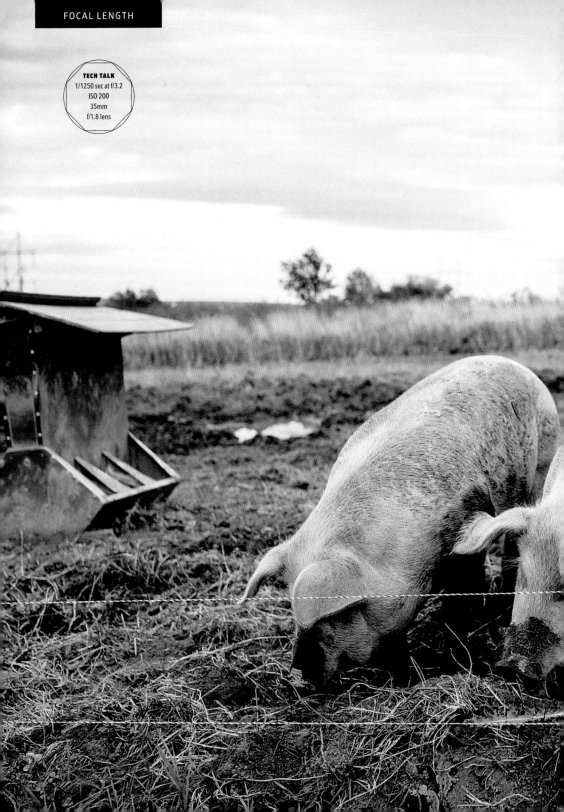

TECH TALK
1/1250 sec at f/3.2
ISO 200
35mm
f/1.8 lens

079 GO WIDE TO SHOW SUBJECTS IN CONTEXT

Coming across these three not-so-little piggies at a farm in upstate New York, *Popular Photography* staffer Stan Horaczek decided to frame an up-close group portrait that would still showcase his subjects in the context of their wider landscape. An experienced shooter, he reached for his 35mm lens—which, on his full-frame DSLR, is a moderate wide-angle lens. This move let him stay a few steps back from the pigs (they are known to bite at most anything they deem edible) while keeping them fairly prominent in the frame. At the same time, the wide angle of view captured the scrubby farm field in the background. Horaczek also used a wide enough aperture to limit the depth of field, which suppressed background detail that could have distracted a viewer's eye from the foreground. To use that aperture, he kept the ISO low and the shutter speed fast—which also ensured that these piggies would stay sharp.

080 LEARN TO SEE WIDE

As nice as the normal focal length is, you may not always be able to fit everything you want in the frame with it—and sometimes there's no room behind you to step back. And you often don't want to take a step back, anyway—you want to stay close to an important element in your picture but take in a lot more of the background. You need a wide-angle focal length.

It's best to start in moderation. You're most likely using a zoom lens that came with your camera, which is good, because it will cover the focal lengths generally considered "moderate" wide angle. Moderate wides are great walking-around lenses, whether in the city or country. (In fact, a number of high-end compacts are equipped with fixed-focal-length lenses equivalent to a 28mm on a full frame.) They are ideal for *establishing shots*—overall views of a scene taken before you zoom in closer on details—in travel photography. You can use these focal lengths for portraits, too, as long as you keep them to half-height. (See precautions below in #081.)

And, of course, they are made for landscapes. Here, exploit a key feature of wide-angles: the ability to take in a near-far perspective that creates the effect of three dimensions. It's not enough to aim your wide angle at an open expanse and click the shutter—it may make a pretty picture but likely not a very interesting one. Instead, do what pro scenic shooters do and arrange your picture in three layers, with an anchor in the near foreground and elements in the middle distance and background.

Camera Format	Wide Focal Lengths
FULL FRAME	24–35mm
APS-C	16–24mm
MICRO FOUR THIRDS	12–18mm

081 BEWARE DISTORTION, REAL OR APPARENT

From the No Free Lunch Department, here are some unwanted visual effects you can get with wides.

DISTORTION This "stretching" is particularly noticeable with people at the edges of the picture, and it's very prevalent in ultrawides. It has a mouthful of a name—*volume anamorphosis*—and is the natural consequence of light rays from the edge of the frame having to travel a greater distance than light rays near the center.

KEYSTONING, AKA TOPPLING With the lens tilted up to take in a tall building, it will appear to be falling backward. This is the way our eyes see, but while our brains correct for it, the lens doesn't. Keep the camera square to structures to avoid it.

THE BIG-NOSE EFFECT You will get it big time if you photograph a person's face close up. This is again how your eyes actually see, but try explaining that to your now-former friend.

082 FIX DISTORTION POST-CAPTURE

You can correct edge stretching and keystoning pretty well in some image-editing software. Note that you may lose some of the picture area with these fixes. As for the big-nose effect, well, your friend may get over it.

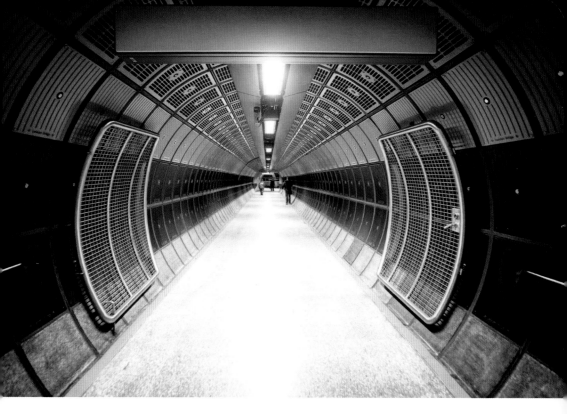

083 GO ULTRAWIDE FOR VISUAL VASTNESS

Something wonderful (and sometimes strange) happens when focal length goes past moderate wide-angle into the realm of the *ultrawide*. The angle of view exceeds that of human vision—often to breathtaking effect. It also lets you manipulate perspective in startling ways.

For example, a 14mm lens on a full-frame camera provides you with an angle of view of 114 degrees. That's huge—both in terms of visual grandeur as well as practical applications. You can offer expansive glimpses of scenes, like this exaggerated tunnel, and (literally) expand the horizons in environmental portraiture. (Think of an artist amid massive sculptural works or an engineer in front of a big bridge project.) At the same time, they can be invaluable in cramped spaces—a small workshop, say, or a cluttered kitchen. Ultrawides give you even more leeway for near-far perspective, which you can accentuate by going with a vertical composition. Just be aware of visual clutter in your compositions—less can be more in ultrawide-angle shots.

These days, most ultrawide-angle focal lengths come packaged in zoom lenses; the 16–35mm zoom, for example, is a popular full-frame lens that covers ultrawide to moderate wide-angle focal lengths.

TECH TALK
1/10 sec at f/3.5
ISO 200
17–35mm
f/2.8 lens

Camera Format	Ultrawide Focal Lengths
FULL FRAME	under 24mm
APS-C	under 16mm
MICRO FOUR THIRDS	under 12mm

084 GO WITH THE SHORT TELE

If a wide-angle lens can be seen as giving you an optical step back, then a *telephoto lens* gives you an optical step (or many steps) forward. Telephotos bring people, animals, and objects closer, sometimes strikingly so. At the longer focal lengths, they can give you a view that is difficult, if not impossible, for the naked eye to perceive, such as the one through binoculars or a telescope.

But no focal length offers a better perspective on the human face (not to mention feline and canine mugs) than a short telephoto. For this reason, they are commonly called *portrait teles*, and sometimes *double normals*,

TECH TALK
1/500 sec at f/5
ISO 640
105mm
f/2.8 lens

because they are around twice the focal length of normal lenses. Short telephoto lenses let you shoot at a comfortable distance—say, 6 feet (2 m)—for a natural perspective, but at double magnification for a closer view. So it's essentially an enlarging lens: It lets you take in the natural view of a normal lens and crop in for more intimate detail—right in the camera. Because you can maintain some distance from a portrait subject, the images will not show the forehead/nose/chin enlargement that very often happens when you get close with

a shorter lens. Another advantage for portraiture: A longer lens is better for limiting depth of field, blurring out distracting detail behind your subject. While justly admired as a portrait focal length, the double normal can do a lot more. It's a detail lens: for focusing in on the grubby hands of a potato picker (as below), intricate beadwork, a fancy dish, fine woodwork, blossoms, and butterflies. These focal lengths also show some *telephoto compression*, in which objects at a distance behind your subject appear "stacked" more tightly in depth than they do in shorter lenses' perspectives.

Camera Format	Short Tele Focal Lengths
FULL FRAME	85–135mm
APS-C	55–90mm
MICRO FOUR THIRDS	42.5–67.5mm

085 FOLLOW THE PRIME DIRECTIVE

Zooms aren't the only lenses you can put on your camera. Many lenses are available in single focal lengths; these are called *primes*, which is not a value judgment— just less of a mouthful than "fixed-focal-length lenses." The great advantage of primes, particularly those in moderate focal lengths, is *speed*—the ability to admit more light. A typical kit zoom might have a widest aperture of f/4.5 at its normal focal-length setting. Inexpensive normal primes, however, are available in f/1.8 maximum apertures, which admit a lot more light, nearly eight times as much. Even faster lenses, such as f/1.2 and f/1.4 (used in the lovely portrait at right), are available. Besides their usefulness in available-light shooting, fast lenses let you limit depth of field much more and provide faster autofocusing in low light.

If you're doing portraits with a kit zoom, the longest focal length will give you good perspective, but it won't let you limit depth of field by very much. The widest aperture available in kit zooms (in any of the three formats) is most always f/5.6. So you may want to consider a prime short tele. Such lenses have apertures at least as wide as f/2.8, and a wide variety of brands and mounts come in f/2, f/1.8, f/1.4, and even f/1.2 variants. The faster the lens, the more expensive it will be, but if you're really getting into portraiture, it may be worth it.

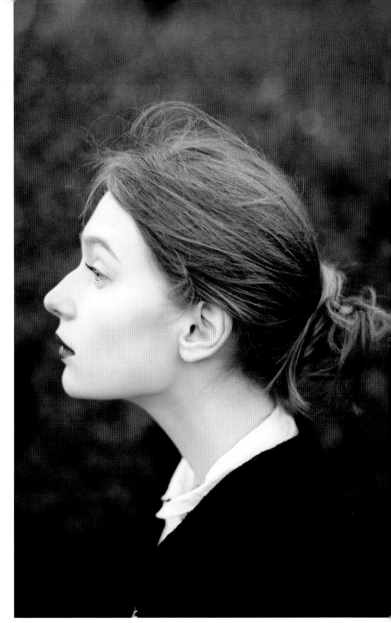

TECH TALK
1/125 sec at f/1.8
ISO 200
50mm
f/1.4 lens

086 SEE LONGER STILL WITH MEDIUM TELES

Here we reach the point where using a long focal length becomes obvious in your photos. Distant objects on various planes will appear compressed; depth of field will be more limited; and the field of view will narrow. And, of course, the view will be close—maybe improbably close, like in this image of a midstroke swimmer. You'll likely use such focal lengths via a *tele-zoom* (a zoom limited to long focal lengths) or an *all-in-one*

zoom (a model that goes from wide-angle to long tele), but there are prime lenses available in these focal lengths, too.

The many uses of a medium tele include shooting sports where you can't get too close; fairly approachable wildlife; and zoo creatures, aerials, and candids at a discreet distance. And while longer teles are

often not considered landscape lenses, you can get striking results in faraway scenes—a valley with hills stacked behind it, say (see the image in #103).

As for drawbacks, these lenses are heavier, so you may want to employ at least a monopod (see #119). They magnify hand shake and, as a rule, are on the slow side aperture-wise.

TECH TALK
1/3200 sec at f/13
ISO 800
70–200mm
f/2.8 lens

Camera Format	Medium Tele Focal Lengths
FULL FRAME	135–300mm
APS-C	90–200mm
MICRO FOUR THIRDS	67.5–150mm

087 TAKE THE PLUNGE WITH A LONG TELE

These are the optical monsters that can capture a lion's eyelashes from the safari vehicle, or the soccer header from the nosebleed seats. They are the mainstays for wildlife and sports from long distances, faraway nature or architectural features, news events, and those "big sun" or "big moon" shots. The compression effect becomes greater still with a long tele, and depth of field can be so limited as to totally blur out a distant background.

Going into very long telephoto territory requires significant commitment, both financial and physical. These lenses are big, heavy, and expensive. Yes, there are some tele-zooms for the smaller formats (APS-C and MFT) that are not so expensive and on the lighter side, but these tend to be quite slow. Search for faster lenses in these ranges, and the price goes up.

Camera Format	Long Tele Focal Lengths
FULL FRAME	400mm and up
APS-C	250mm and up
MICRO FOUR THIRDS	200mm and up

088 RENT TO TRY BEFORE YOU BUY

If you really want to give that 500mm f/4 supertele a whirl, there is an alternative to purchasing it: rental. (Pro shooters do it quite often, if they need a lens for only an assignment or two.) Most rental houses now operate via the Internet, with delivery and return done by express delivery services. Pro tip: Read the rental terms completely before you make the move.

089 REDUCE SHAKE WITH IMAGE STABILIZATION

Lens-based image stabilization is a boon for handholding long lenses. These optics can provide three or even more exposure stops of extra leeway, which translates into, say, the ability to handhold the camera at 1/60 sec with stabilization as opposed to 1/500 without. If your choice comes down to similar lenses with or without stabilization, pay the extra fare.

GEAR GUIDE

090 ADD A TELECONVERTER TO YOUR LENS KIT

A *teleconverter* lets you get a longer focal length without spending big bucks. A 1.4X teleconverter will extend a 300mm lens to 420mm, while a 2X converter will take it to 600mm. The downside: You lose speed, one stop worth with a 1.4X, two stops with a 2X. (Since you're taking in a smaller area of the frame with the converters, you also lose light.) Teleconverters are appropriate only for fast long teles and tele-zooms. The best are manufactured to match specific lenses.

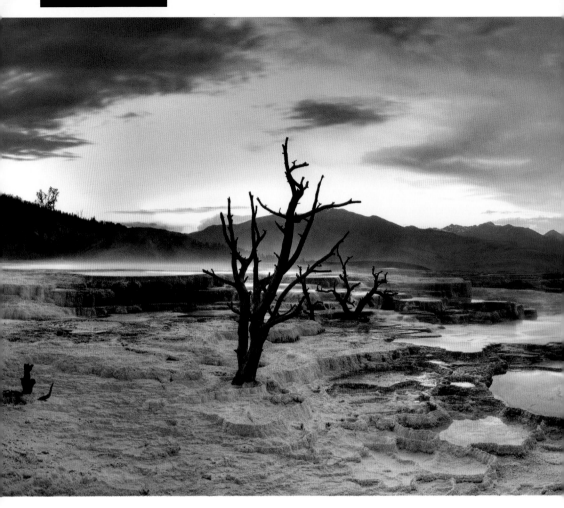

091 STITCH UP A PANORAMA

Panorama has several definitions, but you know one when you see it: a very wide picture showing a vast expanse of our world, outside or in. Digital has revolutionized the making of panoramas—some cameras let you make one by simply sweeping the lens across a scene, with in-camera software doing the rest. But the best panoramas are created by *stitching*: taking multiple shots across a horizontal pan, then combining the images with software. Many image editors have this capability, and there are dedicated stitching programs aplenty.

STEP 1 Set up your camera on a tripod (see #120), with the lens over the rotation point of the tripod head. Aim the camera at your panoramic scene, and level the camera with a bubble level.

STEP 2 Set the focal length on your lens. Avoid the temptation to set a very wide angle, which will make for bad stitching. Keep it to 35mm or longer when using a full-frame camera; 24mm with an APS-C; or 17mm with a Micro Four Thirds model. Do a practice pan and make any tweaks, keeping the camera level.

STEP 3 Aiming your camera at the most important part of your scene, put it in manual mode

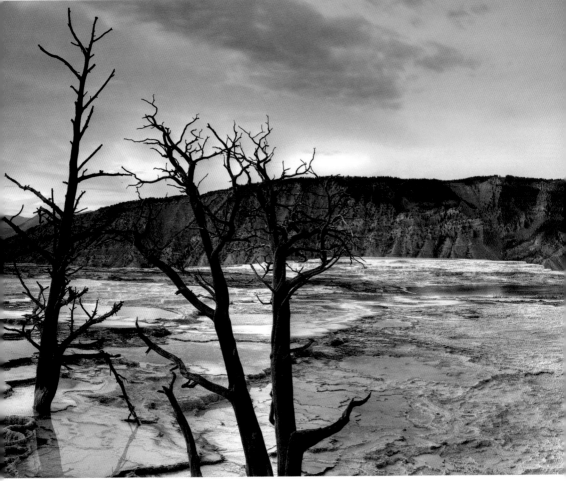

(see #067), set a small aperture (say, f/16), and then adjust the shutter speed to arrive at a proper exposure. To keep your image even in brightness, use this exposure setting for each frame. Similarly, focus manually on the crucial area, then use this focus setting for every frame. For white balance, pick a preset—sunny, cloudy, etc.—and stay in it for the duration of the pan.

STEP 4 Shoot your frames. You want to overlap them by 20 to 25 percent—about a quarter of the width of the horizontal frame. The rule is that no single object should appear in more than two images.

STEP 5 Upload the images to a computer and make any needed edits in image-editing software. Then open the frames in your stitching software, select the images, and hit merge—and enjoy an especially wide view of the world.

FURTHER PHOTO OPS

While panoramas naturally lend themselves to breathtaking vistas in the wild, you can stitch together all sorts of unique views.

URBAN LANDSCAPES Pans work great in public squares and plazas surrounded by buildings, but a long line of buildings can work, too.

DO A 360 Keep shooting overlapping segments until you come back to where you started. You can stitch them together for a 360-degree view–great for virtual-reality tours.

VERTICAL PANS Turn the camera sideways, and take panorama segments vertically of tall structures–buildings, towers–or of natural features–a tall waterfall, a cliff face, a redwood.

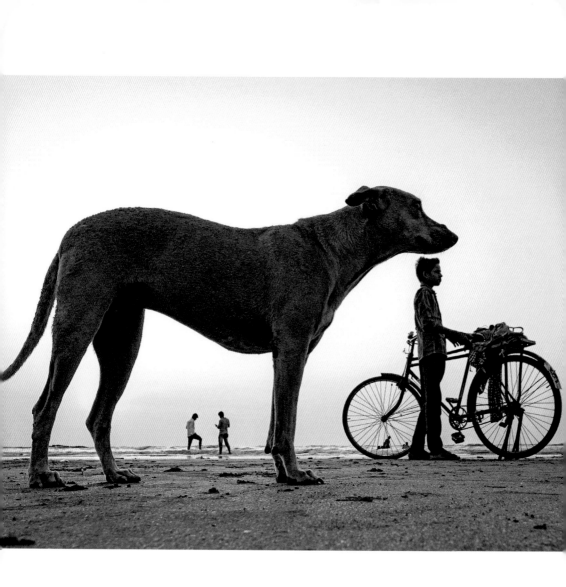

PERSPECTIVE

By now you've seen how much of a difference focal length can make in the look of your photos—how far objects can seem near, small objects look big, and wide expanses appear to be three-dimensional. But there is another factor that exerts as much—if not more—influence over the look of your photos: where you position your camera. We're talking about *perspective*, the appearance of objects in respect to their relative distance and positions. Predominately a function of camera angle and the space between you and the subject, perspective is the view that you offer of your chosen scene, so make it count—try surprising by shooting with a tilted camera, aiming so elements are intriguingly layered in the frame, or positioning your lens for comical tricks of scale, like you see here.

092 EXPLORE PERSPECTIVE AND FOCAL LENGTH

Photographers talk all the time about perspective as if it were a quality inherent in lenses: the looming near-far effect of wide-angles, the natural size relationships provided by so-called normals, and the compression of telephotos. But the focal length of the lens in all these cases can be seen as secondary. Try this to see what I mean: Stand about 20 feet (6 m) away from a large object—a car parked curbside by a house, say. Hold your open hand very close to your face, and see what happens.

Your hand looks considerably bigger than the car. That's because you're getting looming wide-angle perspective. Move closer to the car—around 10 feet (3 m)—and hold out your hand at arm's length. Your hand now appears in a normal size relationship to the car. Now move even closer to the car—say 4 feet (1.2 m)—and again hold your hand at arm's length. The car now appears much larger in relation to your hand. Their close relative distances create this compressed (also called stacked) perspective.

093 PLAY WITH FORCED PERSPECTIVE

The Internet is rife with photos claiming to show the World's Largest Dog, like the big pooch here. This sort of trick imagery, often called *forced perspective*, has been around since the beginning of photography. Using a wide-angle lens (try 24mm on a full-frame camera), find a foreground element and a background element that's far enough away to appear smaller in comparison. Get close so the foreground element looms in the frame, and move around to get a funny juxtaposition with the background element. Use a small aperture like f/16 to keep both front and back elements sharp—crucial to the illusion.

TECH TALK
1/1000 sec at f/6.3
ISO 1000
12mm
f/2 lens

094 GET AN ANGLE ON YOUR SUBJECT

In photography, two issues are paramount for perspective: camera angle and relative distance. Let's look at angle first. Imagine taking a frame-filling photo of a storefront. It may be a very interesting shop window, but it has, fundamentally, no sense of place. Now move to the street corner, and angle the camera to take in the storefront and both intersecting streets. The photo now has another dimension, plus depth and context. Now go across the street to a tall building, and take a shot of the storefront and street corner from a high window. You have added yet another dimension, and still more context. Did you need to change focal length to create these differing perspectives? No.

Portraiture can very forcefully demonstrate the power of angle. Portraits taken straight on, at an angle on either side, as a profile, or as a three-quarter angle from the rear can make subjects look dramatically different. Now change the camera's height—shoot from above your subject's head, and then below it, as in the photos at right—and the same facial expression can look very different. It might even change from wistful to menacing.

095 DO THE TILT AND SWIVEL

TECH TALK
1/500 sec at f/5.6
ISO 100
75mm
f/5.6 lens

Eye level is all fine and good, but the introduction of tilting (and sometimes even swiveling) LCD monitors on DSLRs and ILCs has been a huge benefit for photographers looking to get compositions at odd angles. The classics are the "Hail Mary" shots, with the camera held above crowds or other visual obstructions, and the low-angle shots of kids and pets. But try odd angles for a different perspective in all sorts of shots.

GET LOW Try crouching or lying down for an interesting view of a parade, a dance floor, a full-length portrait (think *Kinky Boots*), or a bug's-eye view of a flower garden.

TAKE IT HIGH Similarly, you might try high for the birthday cake, the rose bushes in bloom, the yard full of kids, or the newly washed and waxed vintage car. You can extend your perspective even farther with the simple, easily portable accessory known as the monopod (see #119). Many monopods can extend to 5 feet (1.5 m), which will allow you to raise your camera 10 feet (3 m) above ground level or more. Or extend your camera out a high window (be careful!) for a scary vertigo-inducing view.

TAKE A LAP Beyond getting up above or below your scene, you should also experiment with walking around your subject to find the best possible vantage point. Try to position yourself so your sights line up nicely, with space between elements to separate them and make each pop, or a clever overlap that allows one of your elements to serve as a background for a more important element.

HOLD THE CAMERA AT AN ANGLE Sometimes, disorientation can be your friend. Try rotating the camera body to an interesting angle to capture a surprising view of a scene.

ONE SCENE, FOUR WAYS

096
ZOOM WITH YOUR FEET

Having a variety of focal lengths, whether by way of a zoom lens or a multilens kit, gives you a seemingly magical power: the ability to dramatically alter the near-far perspective of a scene. You do, however, need another tool to make the magic work: your feet.

You've already learned that it's the distance from your subject that alters perspective (see #092). Move forward, or move back, and the size relationship between your subject and the background changes.

But try keeping your subject the same size in the frame by changing your focal length as you move. You'll see that you can take in a narrow wedge of the background (at telephoto focal lengths), a moderate section (at normal focal lengths), or a wide swath (at wide-angle).

So, learning to "zoom with your feet" will provide more than exercise; it will give you a vital method for strengthening your compositions.

200MM (FULL FRAME), AT 50 FEET (15.2 M) Providing a straightforward, undistorted view, this technique shows little of the background beyond the subject—a compressed perspective. It's good for isolating subjects, particularly with plain and/or out-of-focus backgrounds.

50MM (FULL FRAME), AT 20 FEET (6 M) A more normal relationship between subject and background provides additional context without too much background clutter. This pairing is a natural for portraits.

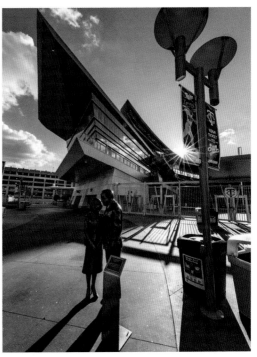

24MM (FULL FRAME), AT 10 FEET (3 M) Now you get a lot more background (or foreground)–and an increased sense of the subject's setting. It's a useful perspective for environmental portraiture, but beware of too much background.

14MM (FULL FRAME), AT 5 FEET (1.5 M) At extreme wide-angle, the subject is no longer the real subject–instead, the environment is. This strategy is still good for some environmental portraiture (think big spaces) and invaluable for photos in which the place is the actual subject.

097 SHOOT UP TO AVOID THE CROWDS

Beautiful places have their drawbacks—namely, lots of people want to photograph them. Anyone who's tried snagging a shot of heavily trafficked sites such as the Taj Mahal or Bolivia's Salar de Uyuni has likely come up with a frame full of tourists. So what's a photographer to do? Skip the ground view, as Yang Lu did here in this shot of Arizona's Lower Antelope Canyon: "I looked up and saw the interesting curvature of the rocks," Lu says. He then maneuvered to find a composition with good leading lines, shot handheld, and took two exposures: one for the rocks and one for the sky. He then blended the two layers in post to achieve properly exposed sky and rock.

TECH TALK
1/8 sec at f/2.8
ISO 160
14mm
f/2.8 lens

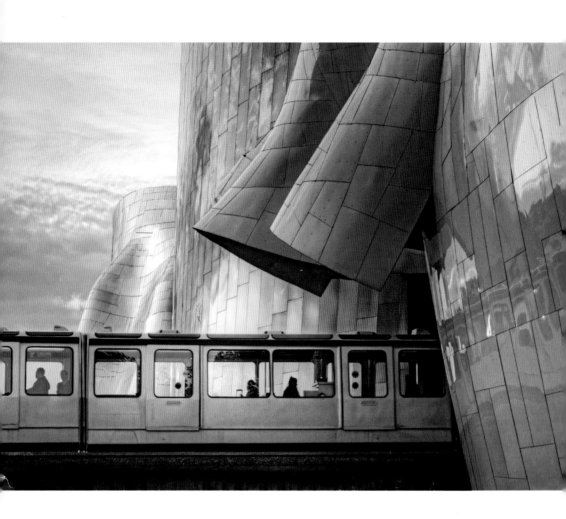

COMPOSITION

What's the difference between a quick snapshot and a photo you'd hang on your wall? Chances are, it's composition: the careful configuration of items in the frame. A successful composition both highlights key visual elements and artfully represents the photographer's view of the world. There are dozens of ways to achieve a dynamic, engaging composition—from moving your main subject just shy of dead center to seeking out eye-arresting patterns, from layering elements for greater depth to filling the frame with a single, in-your-face subject. Many of these techniques arose with painting, so the human eye has a long track record of finding them hard to look away from. And whether you're meticulously arranging objects for a still life or moving around to get the best vantage point on a busy street, you'll still find that the techniques of the old-world masters can help transform your images into something close to outright art.

098 GET A MATHEMATICAL BOOST

A winning composition doesn't just happen. It can take years of experience and focused looking to detect strong shapes and lines. Luckily, a few predecessors came up with handy cheats.

RULE OF THIRDS Rather than plopping your subject front and center, try to place the main action at an off-center point. (You can set your camera to superimpose a nine-square grid over the frame while you get the hang of it.) Forget the squares; instead, shoot so key elements land on the lines. Ideally, your main point of interest (say, a train entering a dramatic—and dramatically lit—building) will fall where a vertical line intersects a horizontal one.

HORIZON RULE Whether your landscape is horizontal or vertical, a horizon line placed dead center in the frame tends to make the picture static. For more dynamism, place the horizon line at one-third positions in the frame. If the landforms or seascapes are the areas of interest, let them dominate by placing the horizon one-third down from the top. But if a beautiful sky is where the action is, place the horizon line one-third up from the bottom.

TECH TALK
1/100 sec at f/8
ISO 400
50mm
f/1.7 lens

099 FILL THE FRAME—OR OPT FOR NEGATIVE SPACE

A solid tactic for making your shots more arresting is to use every inch of your frame—that's right, fill it up, from corner to corner, with your subject and other elements to make it feel packed with visual interest. To achieve this tighter view, you can get physically closer to your subject (if you're not squeamish about, say, a little sweat, as in the image below), or you can use a zoom lens or crop the image later in image-editing software—just be aware that you will lose image resolution with cropping. (A minor caveat with filling the frame: Watch out for stray visual elements near the edges, which can get cut off in weird ways.)

An exception to the frame-filling edict is purposely including *negative space*—the empty real estate surrounding your subject. When used artfully, negative space simplifies a scene and focuses your gaze on the main action. It's especially dynamic to leave empty space for a subject to look into or move toward. For balanced compositions, try giving equal air time to positive and negative space.

TECH TALK
1/250 sec at f/5.6
ISO 100
24–70mm
f/2.8 lens

100 SHOOT THROUGH VISUAL ELEMENTS

Another compelling trick of composition is to photograph through a frame. Try getting up close to a kid peeking through the stair banisters, capturing your neighborhood through the kitchen window curtains, or surprising viewers by shooting a much-depicted monument through a copse of trees. You can opt for strong architectural frames (like doorways or arches), or just permit a smattering of branches to gently creep in around your lens's periphery—the key, as always, is learning to look for these photo ops.

This visual strategy lends your subject context and a layered, dimensional sense of place, while also enhancing depth with strong foreground and background elements. Plus, it naturally leads your viewer's eye directly to your main event. But perhaps most important, framing is a great compositional tool for adding intrigue to an image. Offering a glimpse of an obscured world is like letting people in on a secret, and who doesn't love that?

TECH TALK
1/10 sec at f/8
ISO 100
17–70mm
f/2.8 lens

101 SEEK REPETITION AND SYMMETRY

If there's one thing the human eye never tires of, it's pattern. Repeating lines and shapes provide visual rhythm and lend order to the world's chaos, and they make great photo subjects themselves that can border on abstraction. They're also everywhere: ripples in sand dunes, angular hats of a graduating class, stacks of tires at an auto shop.

Filling your frame with repetitive objects will amplify their effect, but you can also use simple background patterns to set off contrasting subjects in the scene's foreground, adding depth to your photo without distracting from its focus. Even a simple brick wall or decorative wallpaper can do this trick. And watch for ruptures in the flow—when positioned just so in the frame, these breaks in pattern provide a tantalizing place for the eye to rest.

Showcased nicely in this graphic photo of carrots, symmetry is repetition's cousin. With elements echoing across the vertical or horizontal axis of a photograph, symmetry strikes the eye as especially harmonious, creating balance and proportion.

TECH TALK
1/500 sec at f/2.8
ISO 320
24mm
f/1.4 lens

QUICK TIP

102 CHOOSE AN IMAGE ORIENTATION

When it comes to orientation, photos come in three main flavors: *vertical* (also called *portrait*), *horizontal* (*landscape*), and *square*.

Today, most images captured on DSLRs or ILCs are shot in landscape, so one of the easiest ways to distinguish your images is to pivot your camera and shoot vertically—especially subjects that you usually see as horizontal, such as a lake. This trick subverts the viewer's expectations, and it can help focus the eye on an important element—a flower, a bird, or a once-submerged car—in the foreground.

So when should you shoot horizontal? When your subject is wider than it is tall, or if you want to convey velocity as someone travels across the scene. As for square, it's great when you want to revolt against the rule of thirds (see #098) and put a subject smack dab in the middle, or when you want to play up leading lines that pull the viewer through the frame's center.

103 LAYER PICTORIAL ELEMENTS TO CREATE DEPTH

Photos translate the three-dimensional world into a two-dimensional image. Unless you're going for an abstract, flattened effect, you'll want to create a sense of that missing dimension—depth—through composition, lighting, and focus.

TECH TALK
1/20 sec at f/18
ISO 100
100–400mm
f/4.5 lens

In environmental shots, whether indoors or out, draw the gaze deep into the frame by including picture elements in the foreground, middle ground, and background, as in this landscape. It helps to link these visual zones with leading lines (see #104). Bonus points for reinforcing depth with a scene's lighting: By including a full range of light and dark, you create contrast that moves the eye farther into the frame. It also helps to overlap objects with different textures or hues, separating the items and adding to the sense of depth.

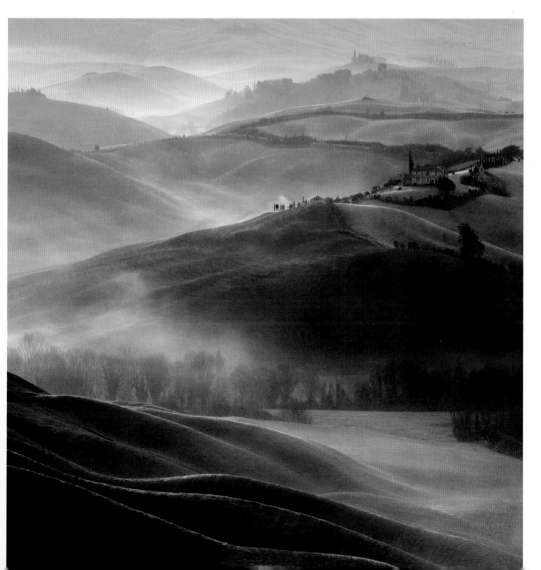

104 EXPLORE LEADING LINES

As a viewer, your eyes consider a line an open invitation. When you see one in a photo, you track it from end to end, following it around the frame and between points of interest. And the route the line takes—straight or wavy, intersecting or parallel—contributes to an image's overall vibe. So look out for interesting sight lines that can focus the viewer's gaze, inject energy, or create an intriguing pattern that the eye wants to linger over.

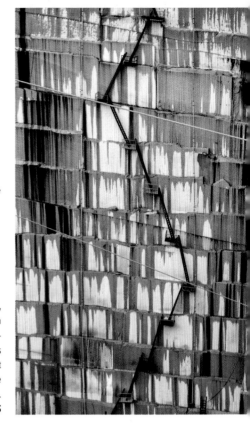

MIX IT UP Vertical lines lead the eye up, calling you to attention, while horizontal lines seem calm. Put 'em both together, and you have a grid that connotes strength and stability—even when the lines are created by impermanent materials, such as the rain streaks on this quarry wall. To add action to a scene, seek out dynamic diagonal lines. Here, the zigzagging scaffolding breaks up the background grid and prompts the eye to move up and down. **TECH TALK: 1/125 SEC AT F/9, ISO 200, 18-200MM F/3.5 LENS**

WALK DOWN THE AISLE Seek out parallel lines that stretch from the foreground to the background—they'll provide both an entry and a landing point for the eye. Here, these vividly colored rows of lavender deliver your gaze directly to the subject: a sole tree at the intersection of the horizon and *vanishing point* (the point at which receding parallel lines appear to converge). **TECH TALK: 1/8 SEC AT F/22, 50 COLOR FILM, 24MM (FULL-FRAME EQUIVALENT) F/4 LENS**

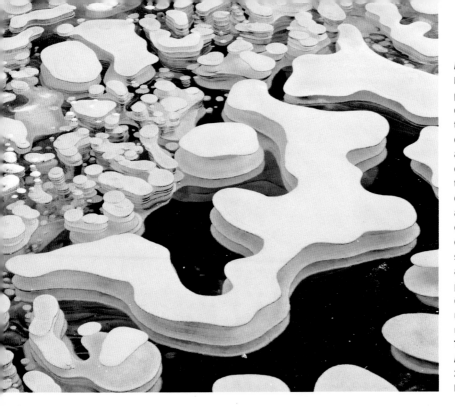

MEANDER A LITTLE

Don't discount the power of flowing contours–they invite the eye to wander deep into the image and all around its edges. Case in point: the repeating organic curves in this near abstraction, which entice you to explore every inch of the arctic scene. Such lines also add a dose of grace, plus a sense of natural order that defies the need for a rigid, man-made grid. **TECH TALK: 1/160 SEC AT F/5, ISO 200, 28-140MM F/2.8 LENS**

SEEK AN S-CURVE

Look for winding lines that make the eye give chase, as in this overhead view of a stairwell in Greece. Its spiral shape leads your view along the queue of donkeys, creating a sense of depth. Look closely, and you'll find S-curves everywhere–in rivers, roads, and walls. **TECH TALK: 1/250 SEC AT F/10, ISO 100, 16-35MM F/4 LENS**

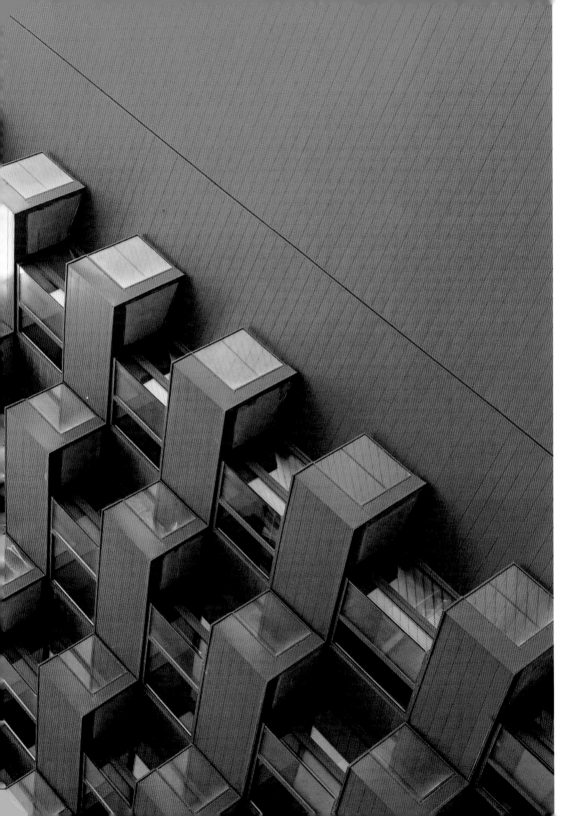

COLOR

There's a saying in photography: "If you can't make it good, make it big. And if you can't make it big, make it red." Tongue in cheek, for sure, but it points to a truth: Color matters. From energetic red to calming blue, each color carries its own visual connotations and emotional impact. Learning to read a color's power—and to identify effective color pairings—will help you capture scenes with a strong color message, aiding your compositions and boosting your images' stop-and-stare factor. Your camera likely offers tons of choices for capturing color. You can set different saturation levels (which affect the intensity of colors) and mimic types of film and film processing, such as black-and-white or sepia. These settings can be fun to play with. But I recommend using neutral settings that contain all of the image and color data from your camera's sensor (see #158–164 for more on shooting RAW), and then altering or tweaking color with software later.

TRY THIS

105 GO BOLD WITH A SINGLE HUE

When you hear the word "monochromatic," chances are you immediately see in your mind's eye a black-and-white or largely gray image. But the photograph at left—with its bright, all-over red hues—is also an example of monochrome, and a powerful one at that. With only one main color, the photographer was able to more effectively isolate shape and line, focusing the viewer's eye on a pattern of interlocking rectangles and diagonals.

To try it yourself, keep an eye out for a largely one-color scene with dramatic texture, contrasts, lines, luminosity, or pattern that really pops against the monochromatic field. Bonus: Select a subject that contains some other shades of your main hue, such as the reflection of darker reds in the windows in our example image. The slightly darker (or lighter) color values preserve the overall color message while providing visual interest and contrast.

SOFTWARE SAVE

106 BOOST COLOR WITH SATURATION

TECH TALK
1/100 sec at f/7.1
ISO 400
18–135mm
f/3.5 lens

The *pixels* (light-gathering cells) on your camera's digital sensor gather light in three channels: red, green, and blue. Software allows you to adjust each of these channels separately to get rid of unwanted colorcasts, add warmth, or deepen tones. You can also adjust overall color saturation using a slider in image-editing software, but use a light touch: There's a fine line between vivid and garish.

107 INJECT ENERGY WITH COMPLEMENTARY HUES

You may be familiar with the color wheel, and perhaps you remember how colors located opposite each other on it were deemed *complementary*. These pairs—red and green, purple and yellow, and blue and orange—do each other a big favor when they team up in an image: They make each other pop, drawing the eye to spots where they meet. This vibrancy even occurs with colors that aren't in exact alignment on the color wheel. Think blue and yellow, or purple and green.

You can wield the power of complementary colors to dramatic effect. Want to make viewers green with envy over how blue the water looked on your Caribbean vacation? Frame the sea with a yellow hallway, as in this shot. Want to make a red blossom appear especially vivid? Compose with some greenery in the frame. Shooting at blue hour with sulfur-yellow street lamps? Don't try to correct the two color temperatures—instead, let their conflicting tones add oomph.

One warning: Complementary colors really give the eye a workout. This is particularly true when the colors are of equal intensity—they can appear to shake or vibrate, which can make viewers uncomfortable. To avoid overwhelming the eye, try to give one color more real estate and relegate the other hue to a supporting role. It's especially effective to use the larger swath of color to draw attention to your photo's subject.

TECH TALK
1/320 sec at f/8
ISO 400
24–70mm
f/2.8 lens

108
HARMONIZE WITH ANALOGOUS COLORS

Sometimes your goal is to soothe (rather than wake up) the eye. In those cases, *analogous* colors—those located side by side on the color wheel, such as the array of blues and greens that you see in the image here—are a great tool for creating unified, harmonious compositions. This palette crops up often in nature; think of all the oranges, reds, and yellows you see in the changing leaves of a tree, for instance, or the blue of a waterfall gushing over green mossy rocks.

Typically, analogous schemes are most successful when one color is dominant, with two or three more acting as backup singers, if you will.

TECH TALK
1/125 sec at f/14
ISO 100
50mm
f/1.8 lens

109 WARM IT UP—OR COOL IT DOWN

There are endless color-wheel combos to explore. But for those of us looking to study less and shoot more, remember this: Cool colors appear to recede, while warm hues seem to advance. That's why bright oranges and reds reach out and grab you, energizing the eye, while cooler blues signal peace and tranquility. This rule affects light, too: The sun's rays at golden hour (see #030) will bathe your scene in a warm glow, while shooting at twilight, in overcast lighting, or in shade will cool it way down.

TIMING

If a photograph is a slice of time, then you'd better learn to carve out the best moments. Much like constructing a quality composition, knowing when to snap the shutter on a scene is more a matter of practice than an issue of technique, but it's also one of the best ways to elevate your images from near misses to dead-on deliveries. It's the skill that will help you craft natural candids of people (instead of awkward portraits) and nail lightning-fast sports events as they happen—not milliseconds after they're over. It's also the skill that will empower you to see fleeting relationships as they take shape before your eyes: telling interactions between strangers on the bus, or eye-popping juxtapositions between passersby and a mural. When it comes to timing, patience and anticipation are your best tools. If you learn to wait for the magic moment, and then see its components come together in time to lift your camera, you'll be well on your way to capturing instants that deserve to last.

110 MAKE THE MOST OF THE DECISIVE MOMENT

You can't talk about timing without mentioning Henri Cartier-Bresson—if he isn't the patron saint of this particular photographic principle, he is at least its doting uncle. He advocated shooting the *decisive moment*, the split instant in which an event completes a scene's potential—say, the second before a leaping man lands in a puddle, in which his body and its reflection in the yet-undisturbed water create symmetry.

Learning to see these instants is key, but the most crucial factor is making yourself available for them. Take your camera everywhere and keep it at the ready, and scout vistas that require one element to be complete: a street that needs a cyclist to speed through just the right spot, or a flock of birds in a stairway about to be disturbed by a woman on her way up. Once you find such a vista, wait out the moment—and then act decisively when it hits.

111 LOOK FOR THE IN-BETWEEN INSTANTS

TECH TALK
1/30 sec at f/2.8
ISO 800
24–70mm
f/2.8 lens

For great candids, take a lot of images to get your subjects accustomed to the sound of the shutter, and hang back to watch for unscripted moments between them. The most photo-worthy instants often masquerade as nothing special. While it's great to have a photo of a family cheesily toasting with their comically decorated cups, the shot at left of Grandma quietly sipping from hers is more subdued and surprising—and so more successful.

112 HIT THE STREETS

The best way to improve your sense of timing is to shoot a lot—and in locales where you can't stage a static composition. There's probably no better place to do this than a busy street, where the hustle and bustle lets you snap scenes as they stream by you.

SIMPLIFY YOUR GEAR Since life happens fast, you may want to park your camera in shutter-priority (S or Tv) mode (see #040), and set a fast shutter speed (1/250 sec) while you control the rest. A moderate wide-angle lens (see #080) is a good choice here.

BE OPEN Instead of imposing your own ideas on a scene, wander around without any preconceptions and see what the world has to offer. You're more likely to create surprising work if you can focus on the scene as it unfolds, rather than engaging your subjects.

DON'T PUSH IT Many people today are suspicious of cameras; be respectful if someone asks you to stop photographing them. (Humility is better than a busted lens any day of the week.)

GO SURREPTITIOUS Rather than keep your camera up near your face, flip up the LCD monitor and view at waist level with live view. This tactic will allow better compositions than the old shoot-from-the-hip method. Or press your smartphone into service as a sneaky trigger. Most cameras now have Wi-Fi and *near-field communication* (NFC), which allow operating your camera via phone app. (No one notices anymore if you have your phone in your face.) Or try setting up your camera on a tripod (or even just on a park bench) and casually snap away via your phone.

EMBRACE AMBIGUITY Often what's compelling in street photos is a sense that something is . . . off. Maybe it's the intriguing balance between people and oversize shadows, as in the shot below. Or it's a recurring color that links unlikely elements and makes you question their relationship. Then there are the faces—people in public often tune out the world, showing strangely contemplative expressions. If a scene makes you curious, it's probably a good one to shoot.

TECH TALK
1/1000 sec at f/10
ISO 800
35mm
f/2 lens

113 NEVER MISS A THING WITH BURST

A great feature of DSLRs and ILCs is their ability to take rapid-fire sequence shots, known as *burst shooting* or *continuous drive mode*. While purists may insist (correctly) that burst is no substitute for timing, many skilled photographers—notably sports, wildlife, and news shooters—rely on burst for must-get shots.

KNOW BURST BASICS Burst mode is a setting found on the same switch or menu as the self-timer (see #118). This control lets you set *burst rate*—the number of pictures the camera will fire in a single second, expressed as *frames per second* (fps). Most cameras allow burst rates between 3 and 6 fps; I recommend 5 fps for most action shooting, like this near collision for a soccer header. Mind your model's *burst capacity*, the maximum number of shots that can be fired before the burst slows down, and use continuous autofocus (see #031) to keep fast-moving subjects sharp.

DON'T LIMIT BURSTING Burst can also be effective for photographing dance and other movement, candids, and weddings. Yes, weddings—for when people cut loose on the dance floor and for rituals like tossing the bouquet.

STUDY UP Know the structure of the game, if you're photographing sports, or the behavior of animal species, if shooting wildlife. Look for tells: the small gestures that signal something big is about to happen.

TECH TALK
1/1500 sec at f/3.3
ISO 400
120-300mm
f/2.8 lens

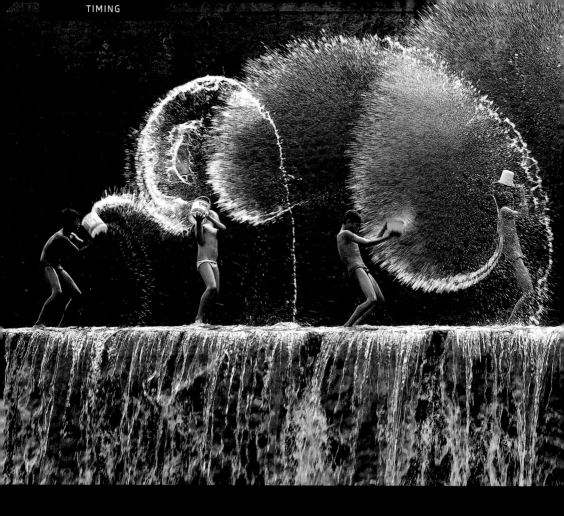

114 WORK WITH SUBJECTS TO MILK THE MOMENT

When you take a photo, you're quite literally capturing a moment in time—from the instant the shutter pops open to the fraction of a second later when it snaps shut. So one of the best methods for creating fantastic images is learning to see truly wonderful moments—as did Malaysia-based photographer Chee Keong Lim when he passed by these children playing on a dam in Bali. "I saw some kids splashing water at each other, and they looked so happy," he says. "I asked them to let me shoot the happy moment, and they immediately lined up neatly and started splashing. One, two, three—and this beautiful picture formed."

In these instants, timing is everything—having your camera ready to go is crucial. But so is being open with your subjects: By politely asking the children if they would play while he took their photograph, Lim was able to extend the magic moment, snapping away until this dynamic composition took shape.

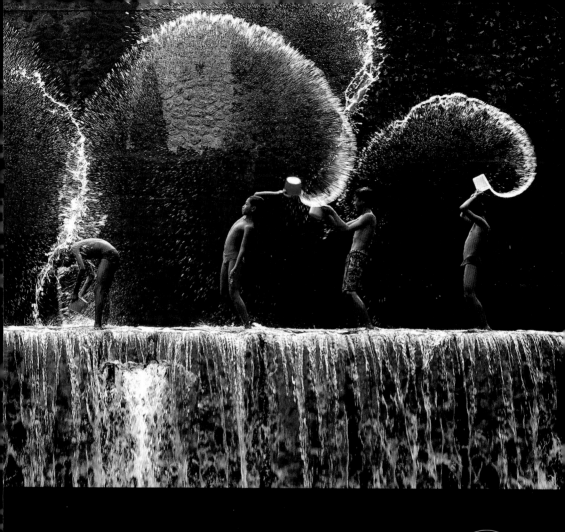

TECH TALK
1/125 sec at f/11
ISO 250
24–105mm
f/4 lens

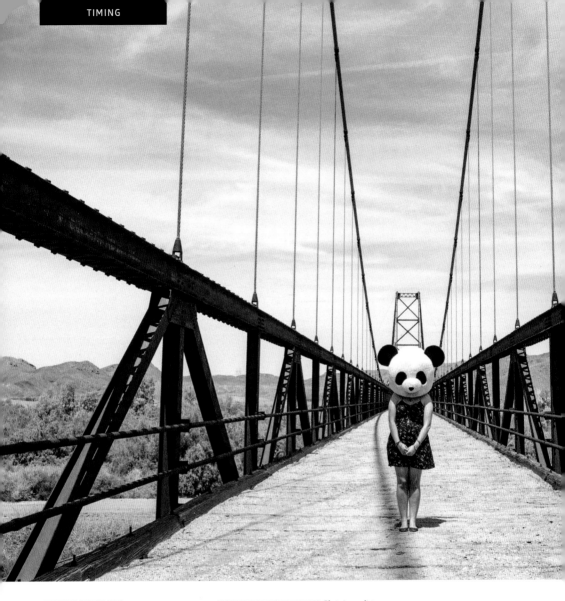

FURTHER PHOTO OPS

Subjects for photo series abound–here are a few more ideas to get your gears going.

SHOOT A SELFIE A DAY One of the easiest ideas is to take a daily photo of yourself. (At least you know the model's always available, right?) Try this at the same time every day: brushing your teeth in the morning, or eating your sandwich at lunch. Keep the composition consistent so the focus is on your face and whatever props you let into the tight crop.

HIGHLIGHT A WORTHY CAUSE Photojournalists often work in the photo series medium, as it allows them to tell rich, nuanced stories about people, places, or issues that often go overlooked. Think about your community–or about the world at large. Is there a story that needs to be told? Do your research, repeatedly put yourself in the right place at the right time, and go about your mission with respect for your subjects.

TECH TALK
1/200 sec at f/11
ISO 100
24–70mm
f/2.8 lens

115
TELL A LONGER STORY

The trouble with a photo is that it's just that—one photo. But what if there's an element you want to explore further, like a place in different seasons, a face as it ages, or a prop that keeps showing up in various places, as in the droll stuffed panda head you see here? When you aren't through with a single image's potential, try transforming it into a photo series and using the medium to tell a story. (Bonus: It's a great way to put your new skills to regular use.)

STEP 1 Pick your narrative—and keep it simple. California-based photographer Cody Bratt started off his series of panda-headed portraits when he wanted to give his landscapes a boost. So far, he's captured friends sporting the mask on bridges, salt flats, and rocky outcroppings in the desert. While each image varies in location, all are woven together by the simple prop. What easy-to-execute concept could you iterate on?

STEP 2 Once you've hit on a series theme, scout for ideas for single shots. If you're shooting, say, the feet of people diving into different bodies of water, keep your eyes peeled for good swimming holes. Or if you're conducting a study of light as it passes through clear surfaces, seek out vases, glasses, and light fixtures with intriguing shapes and details.

STEP 3 Keep everything else dead simple so you can replicate it easily. You want to focus on the theme—not fiddle with camera settings or lights. Here, for instance, Bratt works only in natural light with an occasional reflector.

STEP 4 You're the director, so set your stage. In addition to picking the venues, Bratt often guides the posing. "I direct my subjects to slow down and to not do anything too goofy," he says, which keeps the panda head feeling curious, rather than comical. As you pursue your narrative, you'll develop an instinct about what works best.

STEP 5 Always be ready. It's key to make it easy to squeeze in a few shots and grow your series. For example, Bratt always brings his panda mask on road trips—just in case.

See Better with Next-Level Gear

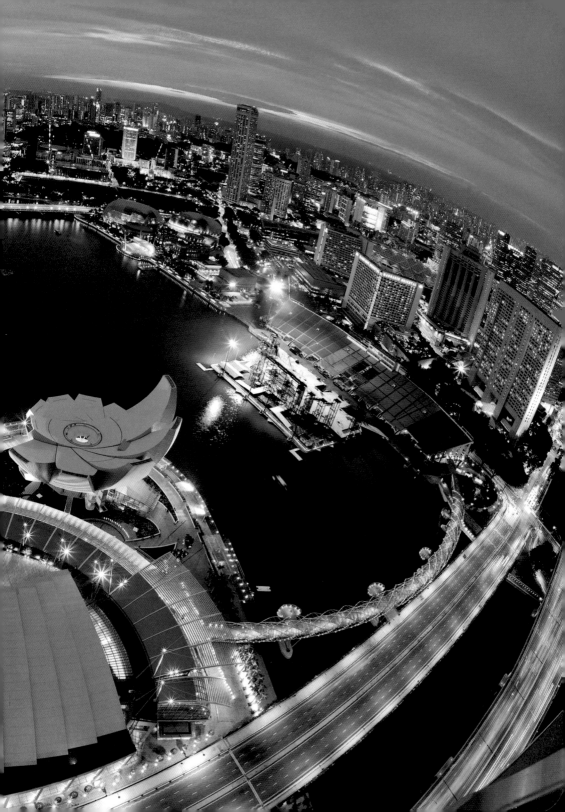

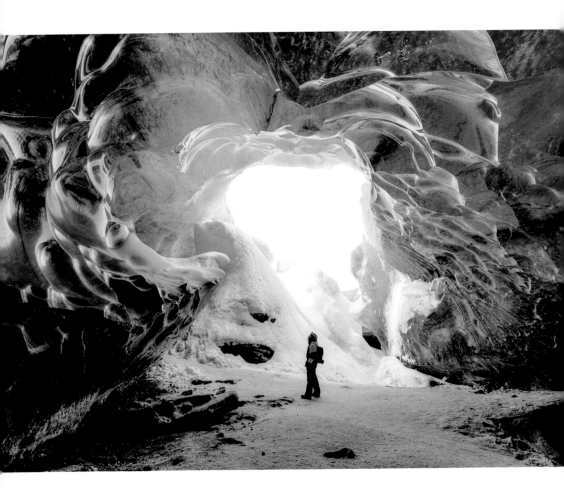

TRIPODS

The *tripod*—also known as the three-legged monster that photographers love to hate—is the piece of photo gear that at first seems the most cumbersome and inaccessible. But it won't take you too long to realize that it can not only greatly improve your picture-taking, it can also add hugely to the fun of it all. For starters, a tripod is your best line of defense against the dreaded image shake, especially if you're working in low light, at slow shutter speeds, or with an especially quaky set of hands. But they're also wonderful tools for creating precise compositions and painstaking still shots. And, when outfitted with the correct head, a tripod can even do what you think it shouldn't: move up and down, and left and right. This dexterity opens up a world of compositional possibilities and takes the strain off your body when you're handholding in an awkward position.

116 PUT A TRIPOD TO GOOD USE

The tripod's best-known function is to keep the camera steady to prevent blurry images. But that's just the beginning of what it can do.

SLOW YOU DOWN Setting up on a 'pod gives you time to preview your scene and decide what belongs (or doesn't belong) in the frame, and which tweaks to make to exposure, framing, and color.

SPEED UP ACTION SHOTS For distant sports or wildlife, a 'pod lets you easily re-aim and/or pan the camera while still quickly operating camera controls.

DO STILL LIFES AND PRODUCT SHOTS You can make adjustments to lighting and placement without messing with your composition.

TECH TALK
1/8 sec at f/11
ISO 100
20mm
f/1.8 lens

USE VERY LONG SHUTTER SPEEDS You already know tripods are fantastic for longer shutter speeds. But they're essential for extremely long shutter speeds—whether you're exposing for a few minutes to achieve the depopulation effect (see #138) or for hours to create star-trail photos (#042).

TAKE PORTRAITS It can be off-putting for a portrait subject to have someone looking at them through a camera. With the camera in live view and on a tripod, you can interact directly and more naturally with your sitter, and direct his or her gaze to the camera just before the shot.

SHOOT FASHION Contrary to its portrayal on TV and in the movies ("Give it to me, girl!"), studio fashion photography involves meticulous, tedious setups of the lights and background, and very little (if any) freewheeling. If you aspire to this kind of photography, boy, do you need a tripod.

TAKE SMOOTH VIDEO Nothing says "amateurish" more than herky-jerky home movies.

DO SELF-PORTRAITS Graduate from selfies to true self-portraits, whether deeply artistic or divinely silly. Use a remote trigger or a self-timer (see #118) to create selfies anywhere—like the one at left.

117 LOOK FOR THE IMPORTANT STUFF IN A TRIPOD

When you're shopping around for a tripod, there's a surprising number of factors to consider.

MATERIAL Tripod legs come in two materials: aluminum alloy and carbon fiber. They're both strong and lightweight, but carbon fiber is often 25 percent lighter and therefore pricier.

Aluminum gets cold to the touch in cold weather, but hey, that's what gloves are for. (Pro tip: Wrap the legs in pipe insulation.)

WEIGHT CAPACITY Tripods are rated by how much they can hold. So be conservative here when you're looking to make a purchase: Take the weight of your heaviest camera rig, add 50 percent or so, and look for a model that's at least that capacity.

LEGS With the legs at full extension, you should be able to look through an eye-level viewfinder without stooping—or at least not stooping too much. The leg sections may lock and unlock by flip-lever locks or rotary collar locks. They're both good options; try each one to see which is more comfortable in your hands.

FEET Almost all tripods have convertible two-way feet: rounded rubber for indoors (or for smooth, hard surfaces outdoors) and spikes for dirt.

HEADS Tripods may be sold bundled with an interchangeable head. In general, avoid tripods with nonremovable heads—they're pretty much always flimsy.

TECH TALK
3.2 sec at f/16
ISO 100
90mm
f/2.8 lens

118
GO HANDS-OFF WITH THE SELF-TIMER

Even with your camera on a tripod, pressing the shutter button ever so gently can introduce vibration in the camera. This is especially prevalent in DSLRs, whose reflex mirrors snap up out of the light path when you press the shutter, producing the noise and vibration known as *mirror slap*.

You can overcome this annoyance by using a wired or wireless remote switch with a time delay, but you already have a widget in your camera that solves the problem: the 2-second self-timer. It may have a dedicated button on the camera, or otherwise be accessed in the drive modes menu. With a DSLR, the press of the shutter button will immediately snap the mirror up; the camera will then count one-Mississippi, two-Mississippi before firing the shutter.

119
MEET THE 'POD SQUAD

Sometimes a full-size tripod is overkill. And sometimes you want to travel light but still have something to steady your camera in a pinch. Other times still, you just plain don't have room for a big tripod. Lucky for you, there are alternatives.

TABLETOP TRIPOD These tripods are convenient for photographing small items like the colorful jacks at left, and they make serviceable field tripods when set up on a picnic table, park bench, or flat-topped boulder. (And they let you shoot from the ground up!) Don't look for cuteness but for sturdiness: Check weight capacity just as you would with a full-size 'pod. Ballheads are universal with these, and some even have *quick-release (QR) plates*—a real plus.

FLEXIBLE-LEG TRIPOD Tabletoppers with a difference: These legs can be bent almost every which way, enabling you to literally tie them around a tree branch, a pipe, a banister, or a chair back . . . you get the idea. Bear in mind the same caveats you would with conventional tabletop tripods: Check your intended purchase's weight capacity and overall sturdiness. QR plates are extra gravy.

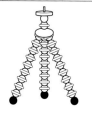

MONOPOD This one-legged support takes your rig's weight off your body, making it popular with sports shooters who work with long, heavy lenses. With just one leg to collapse, it also provides quick mobility. Plus, monopods are great for getting above-the-crowd vantage points; you can fire the camera by self-timer, remote release, or smartphone app. Choose one the same way you would a tripod.

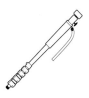

120 SET UP YOUR TRIPOD

So you took my advice and got yourself a tripod—good job. Here's how to set it up so that you fully benefit from its stabilizing superpowers.

STEP 1 Hold the tripod vertically and inverted (with its head toward the ground), and loosen all the leg-section flip locks or collar locks.

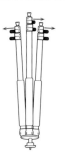

STEP 2 Turn the tripod right side up so that the feet are now toward the ground, and let gravity do its job to pull down the leg sections. If a leg section is stubborn, give it a tug.

STEP 3 Once you're satisfied with the tripod height, retighten all the leg locks.

STEP 4 Put the tripod foot farthest away from you on the ground, then hold the other two legs slightly above the ground and pull them apart until the tripod is fully splayed. (The farther down the legs you grasp, the more leverage you'll have.)

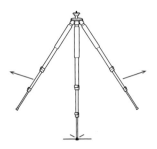

STEP 5 Point one leg directly opposite you, and plant the three tripod feet firmly on the ground.

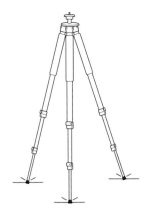

STEP 6 Snap the camera into the quick-release platform of the head and tighten the quick-release lever immediately. Then, one by one, adjust the pan, tilt, and, if necessary, the vertical and horizontal leveling of the head. Be sure to tighten the lock knob for each adjustment before moving on to the next.

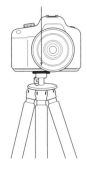

121

KNOW HOW TO GET A HEAD

You may be surprised to learn that your choice of tripod head is usually more important than the tripod itself. Always go with a head that accepts quick-release (QR) plates; these let you attach a QR plate to the tripod socket of your camera—and keep it there. You can then snap this plate into the tripod head you desire and tighten it quickly with a lever. Here are some useful head types.

THREE-WAY Also called a pan/tilt head, this model has separate adjustments for panning (side-to-side movement), tilting (aiming up or down), and horizontal/vertical leveling, with lock knobs for all. It's excellent for nearly every kind of photography, except those that require really fast aiming. It's your best choice for general purpose.

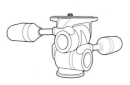

BALL With the release of one lock knob, this head's platform is free to move in all directions. It's great for fast setup in the field and fast, chaotic action, like some sports. It's not so great for slow, careful shooting, such as landscapes and still lifes.

PISTOL GRIP This head type is similar to the ballhead (with the same pros and cons), except the release knob is a squeezable pistol grip. Some recent pistol grips have a trigger that lets you fire the camera shutter without taking your hand off the pistol grip itself—kinda cool.

VIDEO This model is basically a two-way head that gives you the ability to pan and tilt, plus a long aiming lever for fine adjustments. Hydraulic fluid or other damping in the pivot mechanism makes for smooth panning action. It's excellent for video but clumsy for stills—and you can't do verticals.

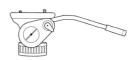

GIMBAL This model is unique in that the camera doesn't rest on the head but hangs from it. This feature lets you mount a very long telephoto lens by its tripod collar at the exact balance point of the camera-and-lens combo, and—with the lock knobs loose—aim it effortlessly at sports or wildlife action. (Gimbals are nearly useless with shorter lenses.)

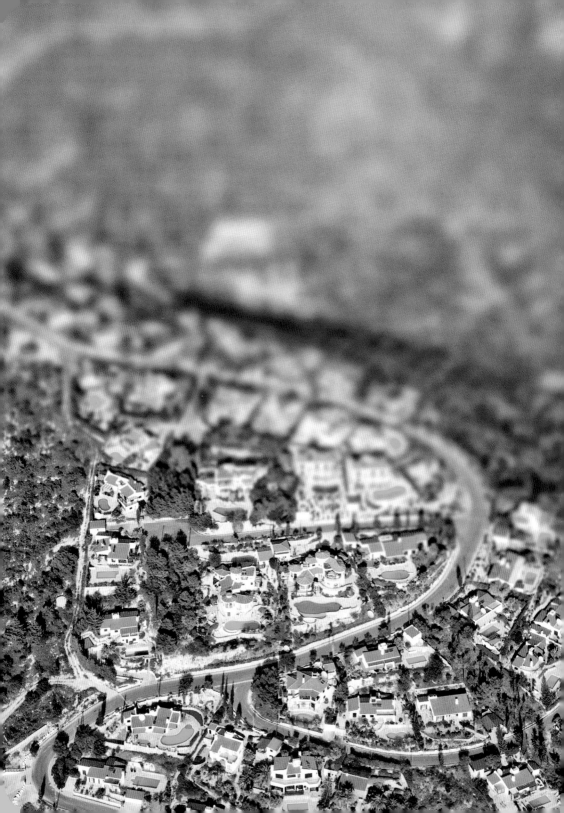

SPECIALTY LENSES

They can be crazy and kooky, brilliant and useful—or all of the above. Specialty lenses—such as tilt-shift, soft-focus, or fisheye optics—let you wander out of familiar territory and achieve shots you simply couldn't create with conventional lenses. They can correct perspective distortion in architectural shots, make a city scene look like a tabletop full of toys, or squash so much real estate into the photo frame that your own feet appear at the bottom of a vast landscape. They can stretch depth of field to seemingly impossible limits, allow you to limit focus on just an eyelash, and make small interiors look weirdly cavernous. Specialty lenses can also help you stretch your photographic muscles in very beneficial ways. They are, by and large, non-autofocus and non-autoexposure, so you'll need to do a little more thinking and planning—always a good thing—and welcome the push into visualizing the world in different ways.

TRY THIS

122 FIDDLE WITH PERSPECTIVE USING A TILT-SHIFT LENS

Certainly one of the most complicated-looking optics around, the *tilt-shift* (TS) *lens* takes the photographic wizardry found in the large-format view cameras of yore—those big rigs whose lenses mount on the front of a bendable, stretchable bellows—and packs it into a modern DSLR lens. (ILC owners: You can purchase an adapter that allows you to use a DSLR version.) Its effects? Several, but its most popular creative application is rendering life-size scenes into charmingly blurred miniatures, like the one you see here.

TS lenses allow two precise movements of the lens: shift, by which you can move it up or down, left or right, while still keeping it parallel to the image sensor; and tilt, by which you can swivel the lens up or down or to either side, all without changing the orientation of the camera. TS lenses are equipped with precision setting, locking knobs, and finely graduated scales. They're available for full-frame DSLRs and are usable on APS-C cameras in the same mount.

Be warned that you'll have to rely on manual focus and manual exposure—although some models offer aperture-priority mode (see #053)—and that a tripod is nonnegotiable. As these lenses are expensive, you might want to rent one to see if it's for you.

123 RIGHT A FALLING BUILDING WITH TILT-SHIFT

If you've ever aimed your camera up to take in a tall building, you've likely run into a common problem: toppling perspective, aka keystoning (see #081). The building will look weirdly trapezoidal, narrower at the top than at the bottom. Our eye-brain system corrects for this distortion, but your camera does not. With a tilt-shift lens, though, you can keep the camera (along with its sensor) parallel to the structure and shift the lens up. The result is an image of the building with parallel edges and perfectly square corners. Tilt-shift lenses do the same trick when you're shooting a structure from up high (from a skyscraper, say). Just shift the lens down, rather than up.

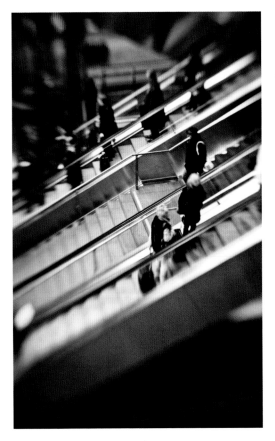

124

GET SELECTIVE FOCUS WITH A LENSBABY

While I generally refrain from referring you to specific brands, it's inevitable when discussing the cool effects of a Lensbaby, as this company pretty much owns this territory. Lensbabies are tilt lenses, but instead of geared precision movement, the lens tilts by way of a simple ball-and-socket joint. You just tilt and swivel the lens freehand any way you want.

While Lensbabies are best known for images with narrow slices of focus, you can—with a little patience—get remarkably increased depth of field. Some Lensbabies are designed to have a sweet spot of sharp focus surrounded by soft focus; others have *drop-in apertures*—little plates that slip into the lens to produce shapes in out-of-focus images. There is also a bendable, squeezable, stretchable lens.

125 GET IT ALL IN WITH A CIRCULAR FISHEYE

Another fun specialty lens is a *fisheye*—the widest of the wide-angle optics. With focal lengths between 8 and 10mm, these lenses capture ridiculous, near-180-degree views, plus wacky barrel distortion.

There are two flavors of fisheye: The first is *full-coverage* or *corner-to-corner*, an optic that spreads the image out enough to cover your entire sensor. The second is *circular*, and it yields a round image surrounded by black (see above). Technically speaking, a circular-image fisheye provides no greater angular coverage than a corner-to-corner fisheye, although it does include more in the image: the areas at the top, bottom, and sides of the circle, which are cropped out by the corner-to-corner models' rectangular frames. To some, a circular fisheye image doesn't pack the impact of a full-coverage fisheye because the image doesn't fill the frame. But these wide circular shots do have a '60s/'70s vibe, so if you're so inclined, dress up in you best tie-dyes, put some Hendrix on the turntable, and groove on the remote shutter release for a pretty far-out self-portrait.

TECH TALK
1/100 sec at f/10
ISO 400
15mm
f/2.8 lens

126 WARP CITYSCAPES WITH A CORNER-TO-CORNER FISHEYE

The 180-degree view of a fisheye lens can be rather discombobulating, but that also makes it ideal for turning the cold rectilinear world on its head. Take, for instance, this skyward shot captured by Nicholas Hill in New York City's Fifth Avenue Apple store. He saw that the translucent landing of the glass staircase turned striding figures into soft, abstract shapes. He aimed his 15mm f/2.8 corner-to-corner fisheye lens upward, capturing both the soles of customers and the soaring towers of midtown Manhattan. The distortion of the lens helped visually connect the two subjects, elevating his picture from good to great.

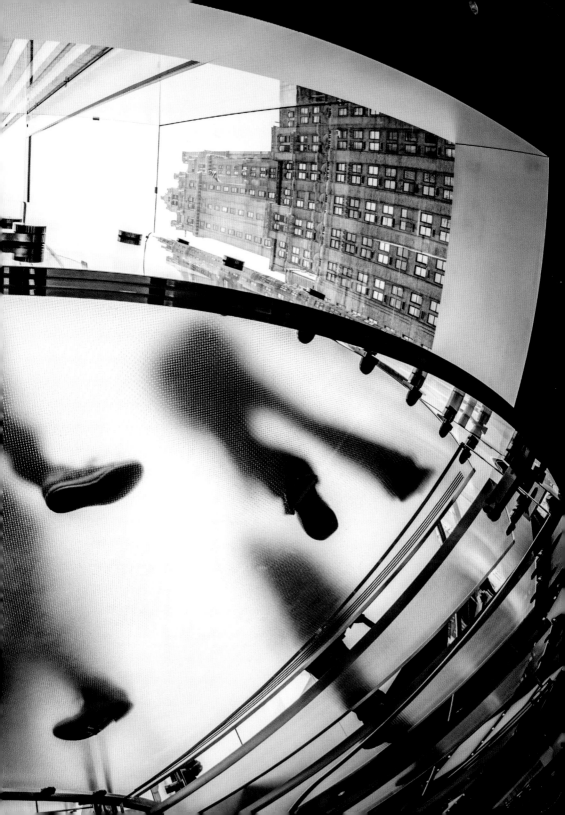

MACRO

Dewdrops clinging to a flower, patterns in a lizard's scales, the iridescent eyes of a bug—tiny objects and creatures provide endless fascination, though their details are often too small to be fully appreciated with the naked eye. While cheap add-on accessories let you take close-ups, a *macro lens*—an optic designed specifically for magnified imaging—will provide the best picture quality and greatest convenience. A true macro lens should reproduce a life-size image on your camera's sensor (see #076); this is called a 1:1 ratio. One of its biggest benefits is that, unlike lens accessories, it performs at the full range of distances from very close to far away. So if you're wandering in the woods, you can go from capturing distant scenics to shooting bugs and blossoms without switching lenses.

127 PICK A MACRO, ANY MACRO

Macro lenses fall into three focal-length classes (see the table at right). The shorter the focal length of the lens, the closer you must be to your subjects for maximum magnification—so with a normal, you'll need to focus on a subject just shy of the lens's front element. Wildlife pros prefer the medium tele macros for their greater working distance, which

Lens	Full Frame	APS-C	Micro Four Thirds
NORMAL	50–60mm	30–40mm	25–30mm
SHORT TELE	90–100mm	60–70mm	50–60mm
MEDIUM TELE	180–200mm	120–140mm	90–100mm

is good for shooting skittish critters in the field. But these lenses are hefty and tend to be very expensive. The short tele may be the best compromise for most shooters—good working distance, reasonable heft, and attractive price—and it doubles as a portrait and candid lens. (With smaller formats, APS-C and Micro Four Thirds, the equivalent focal lengths are proportionally smaller and lighter.)

128 MASTER THE MACRO DIFFERENCE

At high subject magnifications, macros behave differently from plain old lenses. Autofocus can get very cranky, and it will be very frustrating to manually focus—or try to focus—with your lens's focusing ring. It's much more efficient to set the focusing ring at the desired point and then move the camera itself back and forth to achieve focus. For this, a focusing rail is invaluable (see #130). Also, depth of field becomes very shallow at high magnifications—at wide apertures, virtually paper-thin. So for better depth, you'll want to use small apertures, such as f/16, f/22, or f/32 (try one step up from your camera's smallest).

129
KNOW THE
1:1 STANDARD

Macro lenses are rated by their magnification power, with 1:1 being the standard for "real" macro. This ratio, also called life-size, means that the image of an object on the digital sensor is the same size as the object itself in real life. For example, if an image of a 24-by-36mm object (about the size of a U.S. commemorative postage stamp) fills the frame, corner to corner, of a camera with a 24-by-36mm full-frame sensor, that's a 1:1 ratio. A 1:2 ratio is half life-size—so the postage stamp will be that much smaller in the frame when captured by a macro with 1:2 magnifying power.

130
STOCK
UP FOR
MACRO
SUCCESS

FOCUSING RAIL This device mounts to a tripod, and you use it to move the entire camera and lens assembly back and forth to make fine adjustments and achieve focus. Simpler ones consist of a single rail; fancier versions also provide fine side-to-side adjustments for critical composition.

TABLETOP TRIPOD A tabletop unit will let you get closer to miniature objects, which is often convenient when shooting macro. Get a sturdy model—there are a lot of flimsy ones out there.

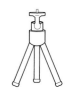

MACRO LIGHT SET This LED light or strobe mounts to the front of a macro lens to capture every tiny detail—minus the pesky shadows. Many models can be set with different light levels on either side.

131
TRY FOCUS
STACKING

Probably the greatest and most startling advancement in macro photography in recent years has been *focus stacking*. It's a nifty solution to an inherent limitation of the genre: the greater the magnification, the shallower the depth of field.

Focus stacking involves taking many digital exposures of the subject, moving the focus point slightly from frame to frame. The in-focus points of those frames are then "stacked" in software. The result: a single image that's sharp as a tack from front to back.

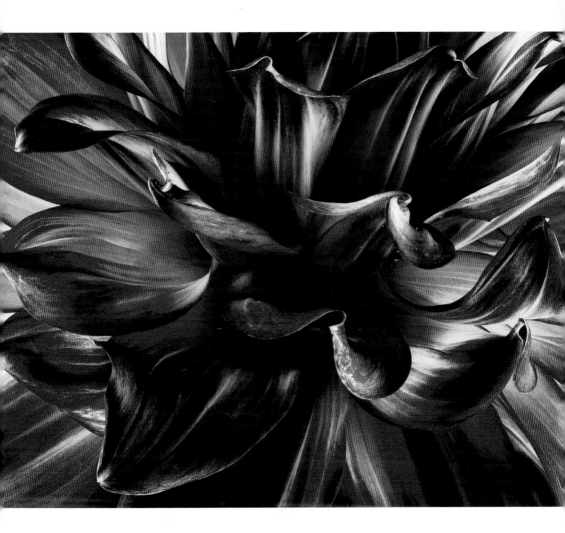

TECH TALK
1/750 sec at f/20
ISO 50
120mm
f/4 lens

FURTHER PHOTO OPS

The world teems with other chances for macro abstractions—once you've dived deep into the details, you won't want to stop! Here are some ideas to investigate up close and personal.

SMALL TOYS To mix up scale for surprise and humor, try going in close on miniature playthings in an oversize environment.

CROSS-SECTIONS OF FRUIT Place very thin slices of vividly colored fruits and veggies on a light box for a backlit exploration of fine patterns in nature.

TINY SPHERICAL SCENES After a storm, hunt down raindrops clinging to leaves, petals, and spiderwebs, then use your macro's magnifying power to capture the reflected world.

TECH TALK
1/200 sec at f/4.5
ISO 200
90mm
f/2.8 lens

132 GO IN CLOSE FOR ABSTRACTION

While macro lenses are the optics of choice for magnifying the miniature world, these workhorses excel at more than closing in on frog feet and bug eyes. Try them out in creating an *abstraction*: a study of color, line, or shape isolated from its context. This close-up picture of a soap bubble offers an intriguing entrée to abstract photography—it's packed with kaleidoscopic colors and eddying patterns that please and tease the eye.

STEP 1 Gather your gear. A DSLR with a macro lens and a set of *extension tubes* (a magnifying optic that fits between the lens and the camera body) are musts. A tripod and macro focusing rail will come in handy, too. You will also need a continuous light source by which to focus, a black background, and diffusion material for the light source, whose output needs to be flat, even, and soft.

STEP 2 Mix the soap solution. A bottle of children's soap bubbles will do the trick (just don't shake it—this can create microbubbles that will be difficult to focus on later).

STEP 3 Set up to shoot. It's best to photograph flat soap film instead of a bubble—which, due to its arc, can be hard to bring into focus. Put a piece of black paper on a surface below your downward-facing camera, and place a clear tray of soapy liquid on top of the paper. Then make a square wire frame that's smaller than the tray—try out 5 by 5 inches (12.7 by 12.7 cm)—and clamp it above the tray. Briefly lift the tray so the liquid coats the frame, forming a flat film.

STEP 4 Start with a constant light source. Keep it bright and diffused, and shoot at a high ISO for the fastest shutter speed possible. Bubble colors are best captured when light bounces off the soap film at a specific angle, so play with your light source. You can also try short-duration flash bursts at low ISOs to achieve sharp but less noisy images.

STEP 5 While it's best to start off shooting a single flat bubble, you can also add intricacy to the soap patterns by using a straw to blow air across the film's surface. What other tactics create interesting patterns and shapes?

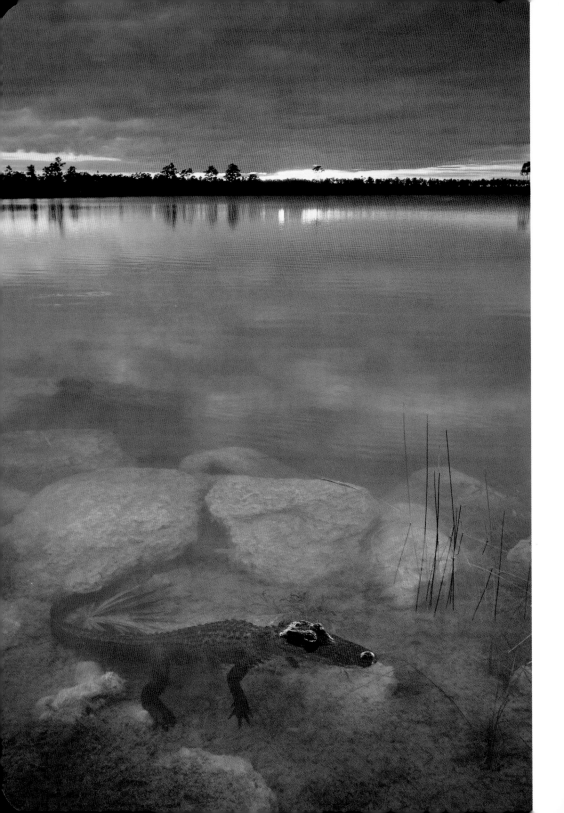

FILTERS

A quaint throwback from your uncle's camera bag? Hardly! Filters are not only still in fashion—they are enjoying a renaissance. They can deepen colors, cut glare, solve contrast problems in landscapes, and enhance outdoor portraiture, all without requiring image editing later. A *filter* is a piece of glass or acetate that attaches to the front of your lens and modifies the light entering the lens to change the effect of the image. Some traditional filters aren't used for digital photography, notably the colored filters designed to alter images taken on black-and-white film, but you can get these effects with electronic filters you already have in your camera. Similarly, adding a tint to a color image can be done easily with a camera's white balance controls (see #061–062).

133 DEMYSTIFY FILTER SHAPES AND SIZES

There are two main types of filters: round and rectangular. The most convenient type, round filters screw into the filter ring of your lens, which will likely be imprinted with its diameter and the Φ symbol (for example, Φ52 for 52mm). If you have lenses with different-size filter rings, buy filters for the largest filter diameter and then use cheap step-up adapter rings to fit the larger filters onto smaller lenses.

Rectangular filters are the second common filter type. They slide into an adjustable holder that mounts onto the filter ring of your lens, and they're available in 2-, 3-, 4-, 5-, and 6-inch-wide sizes, as well as metric versions (ranging from 50 to 150mm). As a rule, figure out which filter holder and size will just fit over your largest-diameter lens, then go up at least one size for leeway.

134 EXPOSE FOR LAND AND SKY WITH A SPLIT NEUTRAL-DENSITY FILTER

An all-too-common problem in landscape shots: If you expose for a bright sky, the land will be too dark, but if you expose for the darker land, the sky will get blown out. Enter the *split neutral-density* (ND) *filter*: a piece of glass or acetate with one clear half and one half tinted a dark gray. Special holders let you slide and rotate these filters to accurately place the transition line so both sky and land are perfectly exposed. It's best done in live view, and if you don't use a tripod, you will go insane.

TECH TALK
1/8 sec at f/9
ISO 100
10-22mm
f/3.5 lens

Take your pick of two: Hard-edge split NDs have an abrupt transition, which is good for distinct horizons or ridges. Graduated split NDs have a feathered transition—better for irregular boundaries between light and dark, as in this moody Everglades scene.

135 PUMP IT UP WITH A POLARIZER

TECH TALK
1/30 sec at f/8
ISO 320
24-85mm
f/3.5 lens

Also called a *polarizing filter*, this is the one filter that you must have, period. It comes in a rotating mount that lets you dial the filter for the desired effect, and it can do things that are hard, if not impossible, to reproduce in image editing later. Without getting into the science of it, a polarizer reduces or eliminates reflections, allowing you to shoot a bank of windows (as seen above), or get deeper tones in a body of water with bright surface reflections. Polarizers also let you darken blue skies on clear days—particularly north sky (see #029)—and will deepen the colors of flowers and green foliage.

QUICK TIP

136 PREVIEW FILTER EFFECTS WITH SUNGLASSES

If you wear polarized sunglasses, you can quickly preview the effect of a polarizing filter through them—just rotate them one way and then the other and see what you like the look of.

137

BLOCK LIGHT WITH A SOLID NEUTRAL-DENSITY FILTER

Solid neutral-density filters are gray, with no color—light black, if you will. They cut down light through the lens to allow for longer exposure times or wider apertures. And why would you want that? Because many scenes are simply too bright to get the effect you want without an ND. Let's say, for instance, you want to blur moving water on a bright day, but you just can't stop down the lens aperture enough to get a slow shutter speed, like the 8-sec exposure that was used to create the blurred cityscape below. Neutral density is measured in 0.3 increments, with each 0.3 representing a full stop. So a 0.9 ND filter will cut the exposure by three stops. NDs are also available as (pricey) variable-density types that let you dial in the darkness—from, say, 2 to 8 stops. You can also stack NDs for even more density.

TECH TALK
8 sec at f/22
ISO 100
24mm
f/2.8 lens

138

HAVE FUN WITH FILTERS

Now that most shooters are all digital all the time, physical photo filters may seem like curious anachronisms. But they're actually more popular than ever, and for very good reasons. Beyond helping you prevent glare or expose for a light sky and dark land, they can also radically affect the aesthetic of your images, including inserting wild yet tasteful starbursts and making pedestrians "disappear." Besides, filters are just plain fun to fool around with. Pick a flavor and try one out.

STAR POWER These star-shape filters can create a majorly '70s (read: cheesy) effect. The trick is to use them where they can work well—like music performances, where flash and dazzle are expected. Many star filters have an adjustable ring, so take test shots with the filter in several positions. As a rule, fewer stars work best. **TECH TALK: 1/6400 SEC AT F/2.8, ISO 4000, 17-35MM F/2.8 LENS**

BOOST COLOR, CUT GLARE Polarizers are beloved by nature photographers: They help deepen blue skies on clear days, tone down unwanted reflections, and boost the saturation of natural colors. **TECH TALK: 3.2 SEC AT F/22, ISO 50, 100-400MM F/4.5 LENS**

SMEAR A DREAMSCAPE This is a trick best for windy days. With the camera on a tripod and an exposure of around 30 sec or more, screw on a solid neutral-density filter—you'll get a strange, counterintuitive blend of blurring fog, water, or whatever else is moving in your frame against a sharp, static background. **TECH TALK: 20 SEC AT F/6.3, ISO 100, 14-24MM F/2.8 LENS**

EPOPULATE A SCENE These two kimono-clad women stood perfectly still during a 15-sec exposure of a bustling Tokyo scene. ther subjects blurred, while many disappeared—all thanks to the so-called *depopulation filter*. You can create this effect with a lid ND filter of high density, which allows for much slower shutter speeds. With a very long exposure (at least 30 sec), moving eople or cars will blur to transparency. **TECH TALK: 15 SEC AT F/14, ISO 100, 24-105MM F/4 LENS**

ACCESSORY FLASH

If you want to hugely expand your shooting options with a single device that fits in a small bag (or a big pocket), get yourself a *through-the-lens* (TTL) *accessory flash*. This flash unit fits into your camera's hotshoe, and it gives you a big boost in power over the small (and wimpy) built-in one. To work its magic, the unit shoots off a preflash when you press the shutter, then analyzes your scene's flash and ambient light through the lens (hence the TTL) to determine the proper flash power and exposure. It doesn't matter if the flash is direct, bounced off a wall, or fired by multiple flashes—the genie inside looks at what's happening on the imaging sensor and figures out the flash exposure automatically. With several TTL flash units, you can also control lighting ratios—that is, set individual units to a different light output to achieve specific effects, such as shadow fill or rim lighting of a subject's hair. With the addition of a few relatively inexpensive reflectors and light modifiers (see #150–157), you can achieve lighting effects indistinguishable from those produced by studio flash units. And with some careful setup, TTL flash lighting can be made to appear much like available light.

139 FILL WITH TTL FLASH

One of the best uses for your accessory flash unit is opening up shadows on your subject with fill flash. A TTL unit shoots off a quick preflash, then uses the bounce-back, analyzed by the camera's meter, to determine how much light to emit when you take your shot. Once you set your flash to

TTL, you're free to set your camera to manual and play with ISO, shutter speed, and other variables to nail the background. In the meantime, TTL flash will take care of the foreground subject for you.

STEP 1 Set your camera to manual and its metering mode to evaluative (see #017).

STEP 2 Set white balance to flash. Choose an ISO, an aperture, and a shutter speed. Be aware: Each camera has a fastest speed that its shutter can capture, or sync, with the flash. You can set your shutter slower, but not faster, than this sync speed. (Don't know your fastest sync speed? Start with 1/125 sec.) If you get confused,

use the program, shutter-priority, or aperture-priority modes to determine your ideal settings, then dial back to manual and plug in those settings.

STEP 3 Take a background shot. Alter the shutter speed or aperture if needed, or use exposure compensation (see #020) to lighten or darken it.

STEP 4 Turn on the flash. Most flashes default to TTL, but if yours does not, push the flash's mode button until TTL appears.

STEP 5 Fire away! The evaluative meter will locate your foreground subject, the flash will expose for it, and the background will look just as you planned.

TECH TALK
1/20 sec at f/5.6
ISO 200
70–200mm
f/2.8 lens

140 GET A BIG BOOST WITH ACCESSORY FLASH

There are tons of great uses for an accessory flash unit.

BOUNCE THE LIGHT The tilting and swiveling flash head can be aimed up at a ceiling or toward a wall to provide soft, diffused illumination on your subject.

TAKE IT OFF-CAMERA The flash can be used separate from the camera, with either a wired or wireless connection, to let you aim the light in a variety of ways.

GANG THEM UP You can use multiple TTL units for wireless, automatic studio lighting setups.

GO STROBOSCOPIC Many flashes feature a stroboscopic multipop setting that allows you to freeze several lightning-fast instants in one image. It's a great tool for making motion studies—say, of golf swings and twirling leaps (like those of the single dancer you see above).

SYNC IT UP Look for a flash with a high-speed pulse setting—it will let you synchronize the flash burst with very fast shutter speeds.

SHINE A STEADY LIGHT Many units have an LED light panel to provide continuous lighting for video.

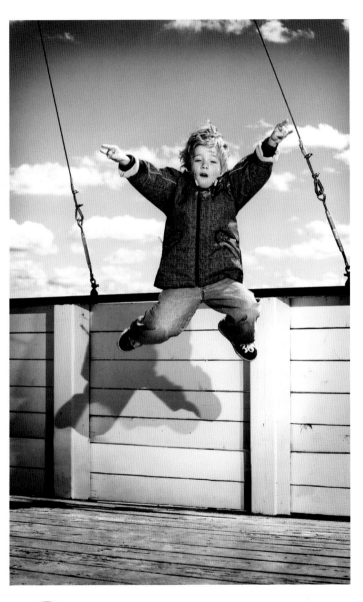

141 FREEZE MOTION WITH FLASH

Jacking up shutter speed (see #039) isn't the only way to freeze action—a flash can do it, too. While a blast from your built-in unit can achieve good results, an accessory shoe-mount flash is the best choice, as it is most effective in low light when you won't have the luxury of using fast shutter speeds. This is the way to go for motion-stopping exposures of dance, gymnastics, and your kid jumping around, as shown here.

The key concept is that the lower the power you set your flash to, the briefer the duration—accessory units can fire off at 1/50,000 sec or even faster. To get the fastest possible flash bursts, turn up your ISO as far as you think reasonable, and position your flash as close as possible to the subject (a remote trigger with an off-camera flash will permit you to do this). If you have sufficient space and time, set up a multiflash arrangement for more three-dimensional lighting.

TECH TALK
1/250 sec at f/11
ISO 100
70–200mm
f/2.8 lens

142 PICK A FLASH

Manufacturers make TTL flash units in three varieties: small, medium, and large. The big units have the highest power, the most bells and whistles, and so of course the steepest price; for a budding enthusiast, they're the best choice. Meanwhile, medium units have good power at a more modest price, and small units work well for taking casual snapshots with the flash on-camera or as an accent light in a multiflash setup. Medium and large units feature zooming flash heads, which adjust automatically to cover your lens's angle of view as you zoom.

The next consideration when shopping for a portable flash is power, which is universally expressed as a *guide number* (GN). Without getting into the math, the higher a flash's GN, the greater its distance range—that is, how far the light will reach. When you compare flash units before purchase, make sure that their GNs are expressed for the same ISO (usually 100), the same units of measure (feet or meters), and the same focal length.

143 SET EXPOSURE WITH ACCESSORY FLASH

With TTL flash automation, you control your accessory flash unit's brightness level by way of flash-exposure compensation, also known as *flash-output control*. This setting raises or lowers the flash exposure in EV steps—the equivalent of stops. It works pretty much the same way you would expect: A flash exposure set at 0.0 EV is the level that the TTL system deems right on the money; a setting of –1.0 sets the flash exposure a full stop darker, and so on.

Some experienced users dispense with TTL automation entirely and set their flash exposure manually by controlling its power. The units can be set to full power, 1/2 power, 1/4 power, and so on down to (usually) 1/256 power. Determine proper exposure by trial and error or with a handheld flash meter.

Note that the exposures for your scene's ambient light and the flash are independent of each other. You can set an exposure to keep the background dark but your subject brightly illuminated, and vice versa, and everything in between. You can thus get many different looks for a single scene.

144 MEASURE FLASH WITH A HANDHELD METER

If you want to use TTL flash units in manual mode, or if you've taken the plunge with studio flash units (big manual flash heads for pro use), a *handheld flash meter* will prove a handy accessory. This meter reads the flash output and provides a readout of the f-stop to set for a proper exposure. You just put the meter in the scene you're photographing and trigger the flash units—the meter needs no wired connection. A bonus: Almost all flash meters can also read ambient light and a combination of ambient and flash.

145 GET THAT FLASH OFF THE CAMERA!

The supreme advantage of a hotshoe-mount flash is that you don't have to keep it in the hotshoe. Here are some ways to get it off-camera.

WIRE IT UP The low-tech method for cameras without a built-in flash, a *TTL off-camera cord* is simply an extension cord that connects your camera's hotshoe and the accessory flash's foot.

TRIGGER WITH THE BUILT-IN FLASH DSLRs and ILCs with built-in flash can control an off-camera flash by *optical pulse*—a brief series of low-power pops from the built-in unit. Typically, you set up the built-in flash for this in a camera menu for flash options.

TRY AN OPTICAL TRIGGER The high-tech method for cameras without a built-in flash, an *optical trigger* fits into your camera's hotshoe and signals an off-camera flash by a near-infrared beam.

GO WITH RADIO WAVES Some high-end flashes can be controlled by radio signal, an advantage for units positioned at long distance or out of the sight line of the camera. You will need a transmitter unit that mounts in the camera's hotshoe.

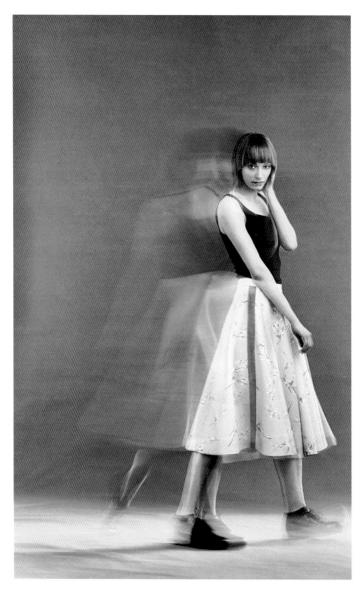

146 EXPLORE GHOSTING WITH YOUR FLASH'S TRAILING SYNC

When you shoot flash photos with a slow shutter speed, moving subjects appear as sharp images amid blur in a phenomenon called *ghosting*, shown at left. Useful in creating dynamic studies of motion, ghosting has one glitch: Sometimes it appears in front of a subject rather than behind it. Since flash synchronization occurs at the start of an exposure, forward motion seems to travel backward, extending the blur in the wrong direction. Luckily, there's an easy remedy.

Set your flash to *trailing sync* (also called *second-curtain sync*), which fires the flash near the end of the exposure and blows ghosting out behind your subject. Experiment with 1/8- to 1/30-sec shutter speeds—the faster your subject, the longer her blur trail.

TECH TALK
1 sec at f/5.6
ISO 200
85mm
f/1.8 lens

147

UNDERSTAND FLASH FALLOFF

Flash is all fine and good, except when it "falls off": fails to reach far enough to illuminate distant objects. It's not as if the light rays lose steam, but they spread out as they travel and become less concentrated.

The beam from a flash unit is cone shaped. Shoot a relatively close object and most, if not all, of the light cone will cover it. But as you move the flash farther away, a smaller portion of the light cone hits the subject as more of the light sprays wide of it. At a great enough

Fraction of light reaching subject	1	$\frac{1}{4}$	$\frac{1}{9}$	$\frac{1}{16}$	$\frac{1}{25}$	$\frac{1}{36}$	$\frac{1}{49}$	$\frac{1}{64}$
Distance in feet	1	2	3	4	5	6	7	8

distance, the flash's light becomes imperceptible to the eye as well as to an image sensor. Even worse? Flash falls off at the square of the distance. In plain lingo, this means that if you move twice as far away from your subject, you get only one-quarter the illumination on the subject. Triple your distance and you get only one-ninth the light.

Solutions? You can make the light cone narrower. If you have an accessory flash with a zoom head, setting the head to tele position will do this. You can also set an accessory unit close to your subject and fire it from a distance via wireless trigger.

148 FIX THE FLASH COLOR MISMATCH

A TTL accessory flash is a great tool for balancing a flash exposure with indoor available light—a classic example being a portrait subject in the foreground of a big room, with the background illuminated by a light source of different color temperature (typically tungsten, the temperature of household bulbs). The problem? If you set the camera's white balance setting for flash (see #061–062), your subject will have a neutral color but the background will be a distinctly different hue due to the ambient light source—in the case of tungsten, very amber. You may not mind this much, but every now and again it'll be truly jarring.

Luckily, the solution is elegant in its simplicity: Just place a gel over the flash lens to match the ambient light. (Many TTL kits come with a few filters; otherwise, they're cheap.) In the example above, you'd gel the flash with an amber filter. You can now set your camera's white balance to match the ambient light, and the flash color will sync with those background lights. Bingo!

ONE SCENE, FOUR WAYS

149
WORK YOUR TTL FLASH FOUR WAYS

Just one TTL accessory flash—and a few reflective surfaces—are all you need to get a wide variety of lighting looks with automatic exposure. For off-camera flash, you'll need a TTL cord connection or a wireless trigger (see #145) in order to sync up your flash with your shutter button.

Note that flash power is an issue with bounce flash. If your flash gives you a maximum 30-foot (9-m)

range, for example, you may think you'll have no problem shooting a subject 10 feet (3 m) away. But if you bounce the flash off a 10-foot (3-m) ceiling, the light has to travel something like 22 feet (6.7 m). And then there's the ceiling—even a bright white one will eat up about a stop's worth of light. Now your effective range is perilously close to the limit. That's why you should get a flash unit with lots of power.

DIRECT FLASH OFF-CAMERA, HELD HIGH While somewhat harsh, it gains something of the look of Hollywood lighting. It also puts the rear shadow lower so it's less distracting.

FLASH ON-CAMERA, CEILING BOUNCE While this technique creates light that is soft and mostly flattering, it creates a classic problem: shadowed eye sockets. It does, however, minimize the rear shadow.

FLASH ON-CAMERA, CEILING BOUNCE WITH REFLECTOR CARD Using a front-facing reflector card–many TTL units have a built-in one, and there are third-party reflector devices–helps fill in the eye-socket shadows.

FLASH OFF-CAMERA, REAR-WALL BOUNCE Aiming the flash backward toward a light-colored wall gives an effect close to that of a softbox.

LIGHT MODIFIERS

You need not be a passive consumer of light. You've seen that simply moving your subject, or moving around your subject, can dramatically alter the quality of light, as can placing an accessory flash in various ways. Now let's add *light modifiers*: devices that can harden or soften light, focus light intensely or spread it over a broad area, add color to it, and even block it selectively. Most are simple, and lots are inexpensive. In general, they fall into two categories: modifiers that reflect light and modifiers that pass light. We'll concentrate here on devices that are reasonably portable, as studio lighting is a topic for, well, a whole other book.

150 STOCK UP ON PORTABLE REFLECTORS

There are two main classes of these helpful light bouncers.

COLLAPSIBLE HOOP These reflectors fold down to about one-third of their opened diameter for easy portability. The five-in-one sets are popular— they combine matte white, silver, gold, and black reflectors, plus a white shoot-through mesh (*scrim*).

FOLDING PANEL Also called a *butterfly reflector*, this model consists of fabric stretched over a light frame, which breaks down for travel. They range in size from 2 by 2 feet (60 by 60 cm) to 8 by 8 feet (2.4 by 2.4 m), in square or rectangular shapes.

QUICK TIP

151 LOOK FOR FOUND MODIFIERS

TECH TALK
1/125 sec at f/5.6
ISO 320
50mm
f/1.8 lens

Light's not fussy—you can modify it with all sorts of materials. Drape a sheer curtain over a window to create soft, diffused light (as at left) or illuminate a subject with a near-lightbox effect, or try shooting through leaves for an interplay of light and shadow. Look around when you're shooting—what could come to your aid?

152 GO WITH DO-IT-YOURSELF REFLECTORS

The entire point of a reflector is to reflect light—to fill in shadows in a portrait, soften harsh sunlight on a wildflower photo, or add just the right boost of light in a dark area of a still life. It's a simple idea, but there are a ton of cheap or free materials that will help you do this, all with their own effects.

SHINY SILVER Opt for this color when you're after fill with more texture. Try crumpling a big piece of heavy-duty aluminum foil, spreading it out again, and wrapping it around a piece of foam core, shiny side out, to get sparkly highlights. Put the foil on dull side out for a more subdued effect.

MATTE WHITE These reflectors are good for soft fill. White foam core, in ¼-inch (6.35-mm) thickness, makes a great diffusing reflector that you can trim to whatever size and shape you want.

MATTE BLACK These dark reflectors (also called flags) deliver *negative fill*: They create a shadow or suppress a hot spot. Black foam core will do the trick.

HELPFUL HINGE A popular DIY setup—among pros, we might add—is the *V-reflector*. Take two big pieces of heavy (½-inch/1.25-cm) white foam core, and hinge them together along their long sides with tape (gaffer works great). Now you can stand the panels up and vary their angle to change up the amount of light on your scene. Try spreading the panels wide to reflect a broad swath of light, or close them down for a more narrow slit of reflectance.

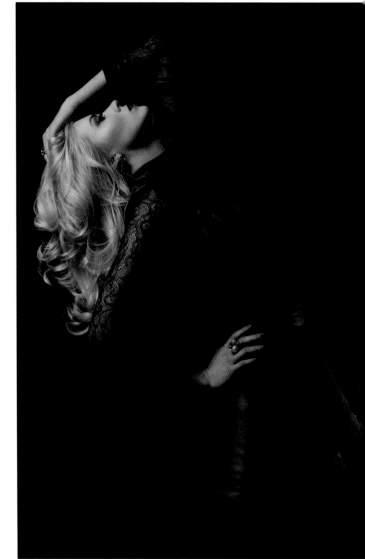

TECH TALK
1/125 sec at f/13
ISO 100
70–200mm
f/2.8 lens

153 MODIFY LIGHT FROM AN ACCESSORY FLASH

If you're working with an accessory flash, you know the drill: Modify that light! Here are some add-ons that will help you out.

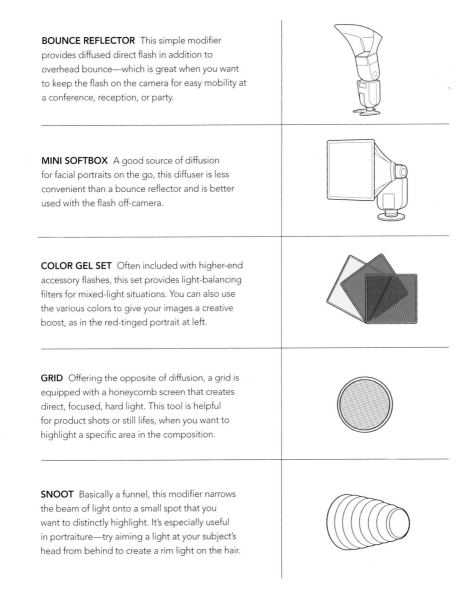

BOUNCE REFLECTOR This simple modifier provides diffused direct flash in addition to overhead bounce—which is great when you want to keep the flash on the camera for easy mobility at a conference, reception, or party.

MINI SOFTBOX A good source of diffusion for facial portraits on the go, this diffuser is less convenient than a bounce reflector and is better used with the flash off-camera.

COLOR GEL SET Often included with higher-end accessory flashes, this set provides light-balancing filters for mixed-light situations. You can also use the various colors to give your images a creative boost, as in the red-tinged portrait at left.

GRID Offering the opposite of diffusion, a grid is equipped with a honeycomb screen that creates direct, focused, hard light. This tool is helpful for product shots or still lifes, when you want to highlight a specific area in the composition.

SNOOT Basically a funnel, this modifier narrows the beam of light onto a small spot that you want to distinctly highlight. It's especially useful in portraiture—try aiming a light at your subject's head from behind to create a rim light on the hair.

154 LET AN UMBRELLA COVER MULTIPLE LIGHTING PURPOSES

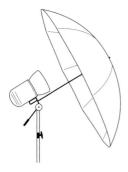

Probably no other lighting device gives you such a range of options as a *photographic umbrella*. This tool has a reflective interior surface designed to bounce light—whether flash or continuous—onto your subject. (And yes, you can use a TTL flash unit with good power as your light source.)

An umbrella both diffuses and, to some extent, focuses illumination, and you can vary the effect widely by changing its angle and its distance from the subject—farther away means harder light, remember, as does a narrow beam of light (see #023 for a refresher on this concept).

One simple version is made of simple translucent white cloth. You can bounce light into it, or aim the light through it to use it as a shoot-through diffusion panel. But most types are designed for bounce only—these come in plain white, reflective silver, or reflective gold. A good compromise is the satin-silver type, which is shiny but not too shiny. You can also add a cloth scrim that fits over the umbrella's opening to mimic the effect of a *softbox* (an enclosed rectangle or square made of diffusion panel that creates a lovely, all-over, soft illumination).

Finally, don't skimp on size—go for an umbrella that opens to at least 45 inches (1.1 m).

TECH TALK
1/160 sec at f/8
ISO 100
85mm
f/1.8 lens

155 SHOOT WITH 45-UP, 45-OUT LIGHTING

With an umbrella and a TTL flash, you can take a classic "45-up, 45-out" single-light portrait.

STEP 1 Choose a place for your portrait subject. Set your TTL flash on the lightstand so that it will fire into the umbrella, and rig flash triggering, either by a long TTL cord or via wireless triggering.

STEP 2 Set a manual exposure on your camera. If your flash has plenty of power, a good first estimate is 1/200 sec at f/8, ISO 100. Set the flash to TTL auto.

STEP 3 Focus on your subject and stand the proper distance from him for the composition you want.

STEP 4 Place the umbrella lightstand so it's an arm's length away from you, to your right or left.

With the flash about level with your subject's head or a little higher, tilt the umbrella so that its shaft is about 45 degrees from horizontal. Keeping the umbrella shaft pointed directly at the set, swivel the umbrella sideways so that it is angled at about 45 degrees from your subject

STEP 5 Take a test shot to see how the light looks. If needed, place a reflector on the opposite side of your subject, also aimed at 45 degrees from his side, but angled up to fill in any facial shadows from slightly below.

STEP 6 You're ready to shoot. If you find that your results are too dark, increase the ISO and/or open up the aperture wider to increase the exposure.

156 HOLD YOUR GEAR STEADY

Unless you have an endless array of friends willing to hold your illumination source or light modifier for you, you'll need a method by which to secure it. Here are some good candidates.

LIGHTSTAND A folding, extendable stand topped with a stud for mounting a wide variety of lights and accessories. Look for ones that can extend up to the height you want and have the weight capacity for the gear you want to attach.

UMBRELLA CLAMP WITH HOTSHOE MOUNT This stabilizer will hold both an umbrella and an accessory TTL flash, and allow for angular adjustments to both.

SPRING CLAMP Many kinds are available, some with additional built-in clamps for mounting several accessories. Useful for attaching portable reflectors to lightstands, tripod legs, and so on.

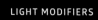

157 OPEN UP SHADOWS IN A WINDOW-LIT PORTRAIT

Photographer Christian O'Dell went beyond the ordinary with this senior portrait, orchestrating the angle, light and shadow, and tonality for an image that feels more like a fashion photo than a yearbook snap. He hung lace curtains in the window to filter the sunlight, creating the romantic, dappled effect and playing off the design of the lace backdrop. The relatively narrow light made for a lovely spotlight on his subject's left eye, but the sharp falloff left one half of her face in darkness. To bring back shape and some detail, O'Dell set a reflector by her torso to open up the shadows on her face while still keeping the overall vibe moody. (Bonus tip: A small LED light stashed at the upper left illuminated detail and color in her hair.)

TECH TALK
1/500 sec at f/3.5
ISO 800
85mm
f/1.2 lens

RAW

Probably no aspect of digital photography scares learners more than the menacingly named *RAW file*. It sounds so . . . untamed. You may be daunted by working in a digital format that doesn't immediately serve up a finished picture but instead a computer file that needs to be worked on, by you, in software, before it's "cooked" as a picture. But working in RAW requires no rarefied knowledge—although, like the rest of photography, you can delve into it as deeply as you want. You already have the software, and for an investment of maybe an hour, you'll be well on your way to learning a powerful picture-making tool. Every digital camera, from a US$29 point-and-shoot to a US$5,000 super-DSLR, makes a RAW file from the info sent from the sensor. It then processes the RAW file into a JPEG—and the point-and-shoot just dumps the RAW. But you can set your camera to store just the RAW file (or both the RAW file and the JPEG made from it) and start benefiting today.

158 DECODE THE ALPHABET SOUP

A RAW file is a big pile of bytes sent into storage by your camera's digital sensor. It amasses everything the sensor was able to record from the scene, given your camera's settings at the time. While we commonly refer to "cooking" a RAW file, a more appropriate analogy is making a print from a film negative. A properly exposed negative contains a ton of information: highlight, midtone, and shadow detail; color information; contrast characteristics; and more. In the darkroom, when making a print from a negative, you can use this info to make the picture lighter or darker, more or less contrasty, shifted toward one color balance or another—and even do these adjustments selectively in different areas. A RAW file (a digital negative) lets you do the same, and the usual "print" is a file called a JPEG.

SOFTWARE SAVE

159 DIG OUT DETAIL IN A RAW FILE

TECH TALK
1/1000 sec at f/2.8
ISO 200
70-200mm
f/2.8 lens

Shooting in RAW is basically an insurance policy. Pictures underexposed or overexposed by as much as three stops can be rescued in RAW conversion, whereas JPEGs might be doomed. Case in point: In the image at left, you could dig out sculptural details from the darkness by using the highlight and shadow tools in image-editing software. Of course, RAW can't fix everything: Areas that are badly overexposed might not contain any detail to dig out.

160 PICK A RAW CONVERTER

To work in RAW, you need a *RAW converter*: software that allows you to make adjustments to your photo and then output it as an image file, typically a JPEG. Check out these RAW converters available to you, in order of increasing sophistication (and price).

IN-CAMERA Most manufacturers put RAW image editors right in the camera so you can make basic adjustments to a RAW file, see the effects on the LCD screen, and store a JPEG on the memory card, all while retaining the original RAW file. A nice start, but the screen is too small to really evaluate the results.

CAMERA MANUFACTURER'S SOFTWARE This software likely came on a disc in your camera package or as a free download. These vary in quality,

but each is designed for your camera's specific RAW files (yes, every manufacturer has its own proprietary RAW format). Sometimes manufacturers will bundle a software boost with more expensive camera models (or sell it at an extra cost). These apps provide a more extensive array of adjustment tools that are comparable to those of third-party software.

THIRD-PARTY SOFTWARE While these provide extensive tool sets for considerable fine-tuning, they also are pretty intuitive for simple tweaks and conversion. An advantage of third-party apps is that they recognize all RAW formats regardless of manufacturer, so if you have cameras of different makes, you can standardize on a single program.

TRY THIS

161 PROCESS AND CONVERT A RAW FILE

RAW software varies, so read the instructions that came with your camera's RAW converter. It will probably go something like this.

STEP 1 Double-click on the icon for the RAW converter software to launch the application.

STEP 2 Use the software's menu to open the folder that contains your photo. The RAW software may recognize a picture folder and open it automatically. If it's not the one you want, go into the menu to select the correct folder.

STEP 3 In most cases, just double-click on a thumbnail of the image you wish to work on. It will appear enlarged in a window, with a checklist of options near

it. Some programs will open the RAW file "as shot" or "camera setting," meaning that it will look much like you saw it on your camera's LCD review. Some programs display the RAW file without adjustments—don't be alarmed; it will look good soon.

STEP 4 Always duplicate the RAW file and store it in a folder (I like to label it "Untouchables") on your computer or a drive. Do this with the Save As command in the program's File menu.

STEP 5 Run down the checklist of adjustments as described in #165. You may be able to apply a preset *JPEG profile*, which will make adjustments

for sharpening, contrast, color saturation, and so on (all of which you can tweak via slider controls). Feel free to experiment, as the adjustments won't be permanent until you convert the file. (Even then, you can always revert to the "as shot" or "camera setting.") Be aware that adjustments might have an effect on each other.

STEP 6 Time to convert the RAW file to an image file; this is usually a Convert or Output command in the File menu. Here you name the file, choose a directory location, and pick a file format. You will most likely want to save it as a JPEG, and you can choose the desired compression level. Hit Save to create the file.

162
GET THE SCOOP ON JPEGS

A universal file format recognized by every operating system, a *JPEG* is an image file processed from RAW data with specific settings: exposure, contrast, white balance, sharpening, color saturation—all the things that make a photo a photo. When you shoot JPEGs, you are simply letting the camera apply these settings, and you can choose from among JPEG profiles, which might be thought of as "recipes" for processing RAW data. You can adjust a JPEG in image-editing software, but only so far before running out of information. This is especially true when correcting for contrast. For instance, you can darken the sky in a landscape, but after a certain point there will be no more detail in the clouds. Likewise, move the slider to lighten the earth, and you may not get much detail—but you may get noise.

JPEG is a compressed format, deliberately shrunk down to take up less memory. Alas, this convenience comes at a price: You'll lose a certain amount of picture information.

163 SAVE AT HIGH QUALITY WITH TIFFS

You need not be limited to the JPEG file format when you're converting a RAW file. If you've done extensive adjustments on a prized image and want to convert it with maximum quality, opt to save it as an uncompressed *TIFF*. This file format has no compression, saving your image with as much detail as possible. This is the file to use for printing or displaying at very large sizes. The catch? TIFF files are ginormous. Depending on your camera's resolution, they can be more than 200 megabytes, which makes sending and storing them inconvenient.

RULE OF THUMB

164 MAKE PHOTOS MULTITASK WITH RAW + JPEG

You can get the convenience and instant gratification of JPEGs along with the power of RAW by doing simultaneous RAW + JPEG capture. Every DLSR and ILC offers this choice in the menu for file format. Here are the advantages.

PREVIEW QUALITY With a full-size, fine-quality JPEG, you can get a glimpse of your starting point for a RAW conversion, along with a JPEG that's perfectly good for many applications.

UPLOAD 'EM You can use the lower-resolution JPEGs for quick sharing via the Internet. Pros now commonly do this to send preview shots to clients and art directors. With the wireless connectivity of many cameras, you can send images to your smartphone, social media, cloud storage, and so on.

SAVE THEM FOR A RAINY DAY If you're still on the fence about working with RAW files, you can take RAW plus high-resolution JPEGs and archive the RAW files for future use.

WEIGH THE DISADVANTAGES The downsides to simultaneous RAW + JPEG capture amount to two: It will take up a lot more space on your memory card (the RAW file will need at least three times as much memory as the JPEG version), and it can seriously reduce burst capture rates.

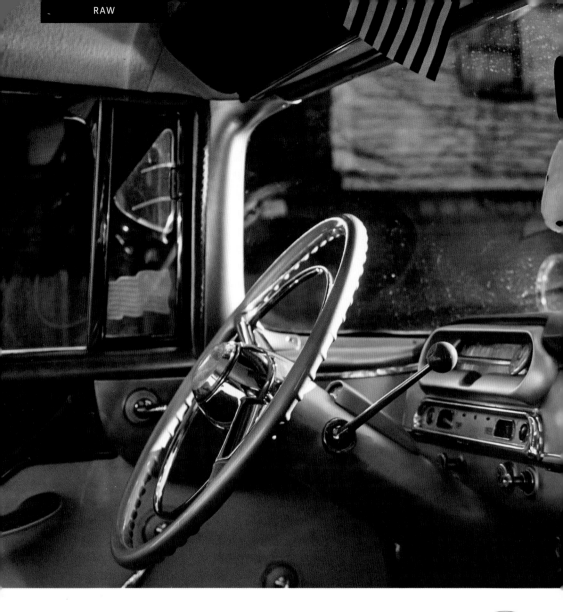

FURTHER PHOTO OPS

Image-editing programs offer an extensive array of adjustments and processes, but a whole slew of specialized programs are dedicated to specific tasks. Here are a few.

BLACK-AND-WHITE CONVERTERS These let you choose from a large selection of specific monochrome looks—including Olde Tyme film stocks—and give you a great range of adjustments, such as contrast, graininess, tint, and so on.

HDR Look for apps that make it easier to create *high dynamic range* (HDR) images: photographs created by merging multiple shots of the same scene that were taken at different exposures. These apps will help you recover detail from underexposed and overexposed areas and show a larger range of tones and colors.

DIGITAL FILTERS If you like the effects of photo filters, but don't want to carry around a pile of glass and acetate, these apps let you apply filter effects digitally— sometimes selectively in areas of the frame.

TECH TALK
1/125 sec at f/5.6
ISO 200
50mm
f/2.8 lens

165 POLISH YOUR PHOTOS IN POST

Maybe you want a little more "snap" in a photo—or a more subdued rendition. Maybe you'd like to see more detail in that shadow—or drop it down to dead black. Welcome to post-production: the adjustment of an image after shooting. The standard of image-editing software, Adobe Photoshop, has huge capabilities for correction, enhancement, and manipulation. But you can get started in "post" with the software that came with your camera.

STEP 1 Address contrast. In most programs, contrast is handled with a slider: Move it to the right for more contrast; to the left for less. Fancier apps have a levels adjustment, which lets you set the black point (darkest) and white point (lightest) and stretches out the intermediate tonal range.

STEP 2 Adjust brightness. This is often called exposure, for good reason—it's the overall darkness or lightness of a photo. Look for a tone that you think should be right in the middle, and adjust the slider until you get it there.

STEP 3 Use the highlight slider to pull down the excess brightness, and the shadow slider to pull up detail in darker areas. You may not be able to restore full detail, however.

STEP 4 Move the white balance slider to shift the photo to a more blue or amber look. You can opt for an accurate rendition—the color balance as you remember it—or to manipulate the hues to create a certain mood (see #065).

STEP 5 While you may want to saturate the colors in vivid scenes (think Mardi Gras), excessive saturation will look very fake. Lower the saturation for a more subtle, low-key look.

STEP 6 Whether you shoot JPEGs or RAW, a default level of sharpening has already been applied to your photos, so sharpen at your own peril. A little bit of sharpening may be okay if you plan to make a large print.

STEP 7 If you want to email or upload your photo, save a new version of the file. Use the picture size panel to set it at 72 dpi (dots per inch), the standard for computer screens, and a modest size, say 5 by 7 inches (12.7 by 17.8 cm).

Resources

GLOSSARY

AMBIENT LIGHT The available light in a scene, whether from natural or artificial sources, that is not explicitly supplied by the photographer for the purpose of taking pictures.

APERTURE The adjustable opening inside the lens, the aperture determines how much light passes through to strike the image sensor. The size of the aperture is measured in f-stops, and higher numbers signify a smaller opening.

APERTURE-PRIORITY MODE A camera mode in which the photographer chooses a specific aperture setting, and the camera automatically selects a complementary shutter speed to achieve a proper exposure.

APS-C An image sensor format used in many DSLRs that's smaller than a full-frame format sensor (and thus captures a smaller angle of view).

ARTICULATED LCD A flip-out image screen that can rotate and swivel away from the camera body, giving the photographer flexibility in the angle of view.

AUDIO FLASH TRIGGER This device allows you to sync your camera with a microphone so that the shutter is triggered by sound rather than the pressing of the shutter button. Useful for capturing very fast action because it eliminates the photographer's reaction time from the process.

AUTOEXPOSURE A mode in which a camera automatically calculates and adjusts exposure settings in order to match an image with the subject as closely as possible.

AUTOFOCUS A mode in which the camera automatically focuses on the subject in a designated point of the LCD or viewfinder.

BACKGROUND The elements in an image that appear farthest from the viewer.

BARREL DISTORTION Distortion in which straight lines curve outward in the image. These barrel-shaped lines are most noticeable along the edges of a photograph.

BOUNCE Light that is redirected toward a subject by a reflector or other reflective surface. Usually soft light, it helps spread light and fill shadows.

BRACKETING The technique of taking a number of pictures of the same subject at different levels of exposure, usually at half- or one-stop differences.

CENTER-WEIGHTED METERING A metering system that concentrates the light reading mostly in the central portion of the frame and feathers out to the edges.

COMPOSITE A picture made of multiple, separate images that have been pieced together with software.

CONTINUOUS (HOT LIGHTS) Traditional tungsten or halogen lights that stay on continuously during shooting.

CONTINUOUS MODE Also known as burst mode, this is the digital camera's ability to take several shots in less than a second with just one press of the shutter button. The speed and total number of frames differs between camera types and models, and is sometimes adjustable.

CONTRAST The range and distribution of tones between the darkest and brightest points in a photograph.

DEFOCUS Defocusing a subject seen through the camera's lens makes it appear softened and less defined.

DEPTH OF FIELD The distance between the nearest and farthest objects that appear in acceptably sharp focus in a photograph.

DIFFUSER Any material that softens and scatters light that passes through it.

EXPOSURE The total amount of light allowed to fall on the photographic medium (determined by aperture, shutter speed, and ISO) during the process of taking a photograph. Also refers to a single shutter cycle (that is, a frame).

EXPOSURE COMPENSATION A feature that lets you increase or decrease your camera's exposure settings in small increments to achieve proper exposure. Usually controlled by a button marked with plus and minus symbols.

FILL LIGHT A technique usually used to soften the contrast in a scene by shining a light that's softer than the main light into a scene's shadows to erase them.

FILTER A camera accessory that can be attached (either screwed on or clipped) to the end of a lens to alter or enhance its effect.

FLASH The brief illumination of a subject during the moment of exposure.

FOCAL LENGTH With a lens focused at infinity, this is the distance from the point in the lens where

the path of light rays crosses to the film or sensor. Longer focal lengths magnify images, while shorter focal lengths reduce magnification and show a wide angle of view.

FOCUS When an element in an image is distinctly defined and its outlines are clearly rendered, it is said to be "in focus."

FOCUS RING A ring on the lens barrel that a photographer rotates to adjust focus manually.

FOCUS TRACKING A camera feature that can calculate the speed of a moving subject in order to properly focus and position the camera's lens to capture it.

FOREGROUND The elements of an image that lie closest to the picture plane, appearing nearest to the viewer in a photograph.

F-STOP A number that indicates the size of a camera's aperture. The larger the number, the smaller the lens opening, which works in conjunction with shutter speeds to accomplish correct exposure.

FULL-FRAME A camera sensor format that has the largest sensor (measuring 36 by 24mm) commonly found in DSLRs.

HARD LIGHT Light that has a narrow focus and falls off quickly into shadow on striking a subject.

HIGH-DYNAMIC-RANGE (HDR) IMAGING A technique in which several versions of the same picture taken at different exposure values are overlaid to get an image with the widest range of tones possible.

HISTOGRAM An electronic graph on a digital camera showing the distribution of tones in an image, from completely dark (on the left)

to completely light (on the right). Displayed on the camera, it's a useful tool for determining whether an image contains the correct range of tones for a proper exposure.

HOTSHOE A connector on top of the camera, where accessory flashes and other devices can be mounted to sync with the camera.

HYPERFOCAL DISTANCE The closest distance at which a lens can focus while keeping objects at infinity in acceptably sharp focus. It varies with f-stop. Landscape photographers exploit hyperfocal distance to create the feeling of deep space in photos.

IMAGE SENSOR The medium in the camera that captures light and converts it into an electric signal.

IMAGE STABILIZATION A camera or lens function that can be switched on to reduce blurring created by the movement or jostling of a camera during an exposure.

ISO The setting that regulates a camera's digital sensitivity to light. The higher the ISO, the greater the sensitivity, and the greater the low light and/or high-speed capability.

JPEG The most common type of image file, useful because it compresses images into convenient sizes and can be read on any platform. JPEGs can be resized easily in image editors; large ones are suitable for most image edits and for large prints and viewing on big screens. Small files are ideal for emailing and web use. High levels of compression will cause more data loss and image degradation.

LCD (liquid crystal display) A thin, flat display screen on a digital camera that provides a live feed

of what the camera is seeing, allows you to play back images after shooting, and offers access to menus and information such as exposure settings, autofocus points, and histograms.

LENS FLARE Unwanted degradation of an image caused by light scattering inside a lens, resulting in odd spots, streaks, and veiling fog.

LIVE VIEW A function that sends the image through the lens to the LCD rather than the optical viewfinder. Using this function affords a larger view of the frame, easier depth-of-field preview, magnification for manual focusing, and other benefits. But it can be hard to use in bright light and when shooting handheld.

MACRO Close-up photography of very small subjects. The image on the sensor is close to the size of the subject or even larger.

MIDGROUND The elements of a photo that appear to lie in the middle of the space relative to the viewer.

MOTION BLUR The streaking in an image that results when either the subject or the camera moves during exposure.

NOISE Undesirable graininess and flecks of random color in a portion of an image that should consist of a single smooth color. Noise in an image generally increases with higher ISOs.

OVEREXPOSURE When too much light strikes the sensor, the image is overexposed, meaning its colors and tones appear very bright or white, and highlighted areas are washed out.

PANNING The horizontal movement of a camera along with a moving subject. The technique is used to suggest fast motion, and brings out the subject from other blurred elements in the frame.

PANORAMA An image that depicts an extremely wide angle of view, typically wider than the human eye can see and than most lenses can capture. Often created through compositing.

PENTAPRISM A multisided device built into a DSLR that corrects the orientation of the image and directs it to the viewfinder.

PIXEL The smallest single component of a digital image. Also refers to the light-gathering cells on a camera's sensor.

POST-PROCESSING The work done with software on an image after a camera has captured it. It ranges from converting the image into a different type of digital file to editing and altering the picture.

PRIME LENS Any lens that has a fixed focal length, as opposed to a zoom lens, which has a variable focal length.

RAW FILE Also known as a digital negative, losslessly compressed RAW files are created in your camera. To output them, you must modify them with a converter, such as the one provided with your camera. RAW files allow you to alter camera settings, such as white balance, after the fact, and provide the most possible original data in an image.

REFLEX MIRROR A mirror that reflects light coming through the lens upward to the pentaprism for viewing through the optical viewfinder. It then pivots up when the shutter is pressed, creating a path between the lens and the image sensor.

RULE OF THIRDS A compositional guideline stating that visual tension and interest are best achieved by placing crucial elements of a photograph one-third of the way from any of the frame's edges.

SATURATION The intensity of color in an image. A saturated image's colors may appear more intense than the colors did in the actual scene, an effect that can be achieved with software.

SELF-TIMER A camera mode that gives a predetermined delay between the pressing of the shutter release and the shutter's firing. Can be used on a tripod-mounted camera for self-portraits or to eliminate the effects of camera shake when you press the shutter.

SHUTTER A mechanical curtain that opens and closes to control the amount of time during which light can reach the camera's image sensor.

SHUTTER-PRIORITY MODE A camera mode in which the photographer chooses the shutter speed, while the camera automatically adjusts aperture to achieve a proper exposure.

SHUTTER SPEED The amount of time during which the shutter stays open to light, generally measured in fractions of seconds. (1/8000 sec is a very fast shutter speed, and 1/2 sec is very slow.)

SINGLE-AREA AUTOFOCUS A shooting mode in which the camera focuses on a specific element or point within the frame.

SOFT LIGHT Whether diffused or coming from multiple or broad sources, this light falls on a subject without casting deep shadows or creating much contrast.

SPOT METERING A camera function that measures the light in only a small area, generally in the center of the frame. Use this feature when you want to precisely meter a particular point or element, and don't want other areas of the scene to affect the exposure.

TIFF A type of digital image file that is great for editing with software because it retains image quality and doesn't compress files.

TUNGSTEN LIGHT An incandescent type of continuous lamp that gives warm-toned light.

UNDEREXPOSURE When too little light strikes the sensor, the overall tone of an image is dark, shadows are dense, and colors are muted.

VIEWFINDER The opening the photographer looks through to compose and (if using manual focus) to focus the picture. A viewfinder can be electronic or optical.

WHITE BALANCE This camera setting defines what the color white looks like in specific lighting conditions and corrects all other colors accordingly.

ZOOM LENS Any lens that is constructed to allow a continuously variable focal length, as opposed to a prime lens, which has a fixed focal length.

ZOOM RING A ring on the barrel of a lens that, when rotated, changes the focal length of the lens.

INDEX

ILLUSTRATION CREDITS

All illustrations courtesy Conor Buckley.

PHOTOGRAPHY CREDITS

All photos Shutterstock unless listed below.

Front endpaper: Abdulaziz Alasousi p.1: Stocksy p. 2: Stu Collier pp. 4–5 (left to right): Philip Ryan, Shane Wheel, Sarah Belin, David Bowman, Yang Lu, Ian Plant p. 8: Stocksy pp. 10–11: Stocksy 011: Catherine MacBride pp. 22–23: Suryo Ongkowidjaja 014: Alan Lawrence 016: Joshua Zhang 019: Todd Klassy 020: Christian Chaize 022: Lewis H. Abulafia 024: Alissa Everett 025: Phil Chester 026: Bob Larson 027: Stocksy 028: Pascal Shirley 030: Ian Plant 032: Philip Ryan 038: Todd Hunter McGaw 039: Jef Russell 043: Masahiro Miyasaka 045: Chris Tennant 047 (clockwise from top left): Stu Collier, Ian Plant, Brian Donovan, David Bowman 048: Patrick Rochon 049: Ian Plant 052: Photography by Lynn Saville from her book Dark City: Urban America at Night 054: Susan Taylor 055 (left to right): Abeselom Zerit, Flickr 056: Sarah Bourque 058: 500px 059 (clockwise from top left): Cathryn Gallacher, Sarah Belin, Jill Mazur, Marsel van Oosten 060: Jill Reger 063: Jeff Wuerth 065: Chris Tennant 066: J. Bryce Bordenkecher 070: Kyle Dreier pp. 86–87: Levent Erutku 076: Jeffrey Milstein 078: Jay Huang 079: Stan Horaczek 083: Matthias Haker 084: Stocksy 085: Egor Sechin 086: Dennis Murphy 091: Rodney Lough Jr. 093: Neenad Arul 094 (middle): Christophe Debon 094 (bottom): Anita Bowen 095: Jeffrey Milstein 096: Ian Plant 097: Yang Lu 098: John J. Matzick 099: Dustin Snipes 100: Dillon Saw 101: Audra Mulkern 103: Krzysztof Browko 104 (clockwise from top left): Don Jacobson, Darwin Wiggett, Andrew Shum, Charlie Waite 105: Loic Vendrame 107: Scott Cramer 111: Lucy Schaeffer 112: Richard Bram 113: Ron Wyatt 114: Chee Keong Lim 115: Cody Bratt pp. 130–131: Glen Espinosa 116: Shane Wheel 117: Stan Horaczek 126: Nicholas Hill 128: Paul Souders 131: Peter Samuels 132: Linden Gledhill 134: Paul Marcellini 135: 500px 137: Luis Figuer 138 (top left): Dan Bracaglia 138 (bottom left): Ian Plant 138 (top right): Dany Eid 138 (bottom right): Cole Thompson 139: Joe McNally 140: Joe McNally 141: Michel Roy 146: Stocksy 149: Stan Horaczek 152: Jesca Cluff 154: Derek Yarra 157: Christian O'Dell 159: Stocksy 165: Stocksy pp. 180–181: Stocksy p. 192: Jill Mazur Back endpaper: Stocksy

AUTHOR ACKNOWLEDGMENTS

While my name appears on the front cover, this book is fundamentally the creation of the team at Weldon Owen, led by the redoubtable Lucie Parker. They are the ones who did the heavy lifting—sourcing photos, obtaining rights, creating illustrations, designing pages, and sanding down my Deathless Prose. Thanks to all my colleagues at *Popular Photography* for letting me freely consult with them, with a special shoutout to Debbie Grossman for her help on software topics. My greatest appreciation goes to the Editor-in-Chief whom we call, with both affection and respect, Boss Lady: Miriam Leuchter. I am honored to have her as a leader, a colleague, and a friend. She convinced me to take on this book project, despite my heebie-jeebies. I'm glad she did.

PUBLISHER ACKNOWLEDGMENTS

Weldon Owen would like to thank Kevin Gan Yuen for managing image permissions, and Marisa Solís, Katharine Moore, and Kevin Broccoli and Laura Chu of BIM Creatives for editorial assistance. Extra special thanks go to Ian Plant and Stan Horaczek for additional photography.

POPULAR PHOTOGRAPHY

P.O. Box 6364
Harlan, IA 51593
www.popphoto.com

POPULAR PHOTOGRAPHY

Editor-in-Chief **Miriam Leuchter**
Art Director **Jason Beckstead**
Features Editor **Debbie Grossman**
Senior Technology Editor **Philip Ryan**
Assistant Technology Editor **Adam Ryder**
Assistant Editor **Sara Cravatts**
Group Photo Editor **Thomas Payne**
Photo Editor **Fiona Gardner**
Contributing Editors **Richard Bernabe,
Tim Fitzharris, Peter Kolonia, Harold Martin, Ian
Plant, Dan Richards, Julia Silber, Jeff Wignall**
Popphoto.com Editor **Stan Horaczek**
Assistant Online Editor **Jeanette D. Moses**
Editorial Production Manager **Glen Orzepowski**

ABOUT POPULAR PHOTOGRAPHY

With more than 2 million readers, *Popular Photography*
is the world's largest and most noted photography and
image-making publication. The magazine brings more
than 75 years of authority to the craft, and in its advice-
packed issues, website, and digital editions, its team of
experts focus on hands-on how-to hints and inspiration for
everyone from beginners to top-notch professionals.

Popular Photography is a division of **BONNIER**

weldon**owen**

Weldon Owen is a division of Bonnier Publishing USA.
1045 Sansome Street, Suite 100
San Francisco, CA 94111
www.weldonowen.com

WELDON OWEN

President & Publisher **Roger Shaw**
SVP, Sales & Marketing **Amy Kaneko**
Finance & Operations Director **Philip Paulick**

Senior Editor **Lucie Parker**
Editorial Assistant **Molly Stewart**

Creative Director **Kelly Booth**
Art Director **Lorraine Rath**
Freelance Art Director **Jennifer Durrant**
Senior Production Designer **Rachel Lopez Metzger**

Production Director **Chris Hemesath**
Associate Production Director **Michelle Duggan**
Imaging Manager **Don Hill**

A WELDON OWEN PRODUCTION
© 2016 Weldon Owen Inc.
All rights reserved, including the right of reproduction
in whole or in part or in any form.

ISBN 13: 978-1-68188-110-2
ISBN 10: 1-68188-110-1

10 9 8 7 6 5 4 3 2 1
2016 2017 2018 2019 2020

Printed in China by RR Donnelley.